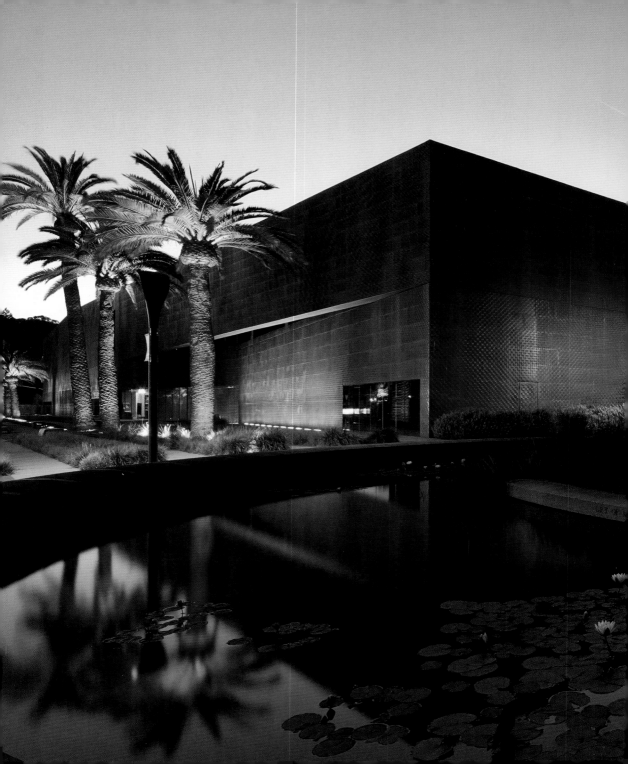

de Young | Inside and Out

INTRODUCTION BY Ann Heath Karlstrom

NEW PHOTOGRAPHY BY Henrik Kam

PUBLISHED BY THE Fine Arts Museums of San Francisco

SPACES | Collections

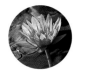
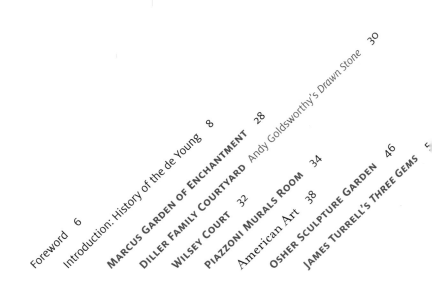

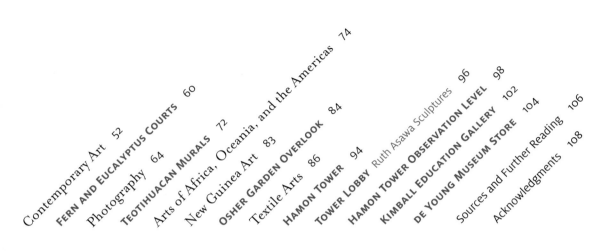

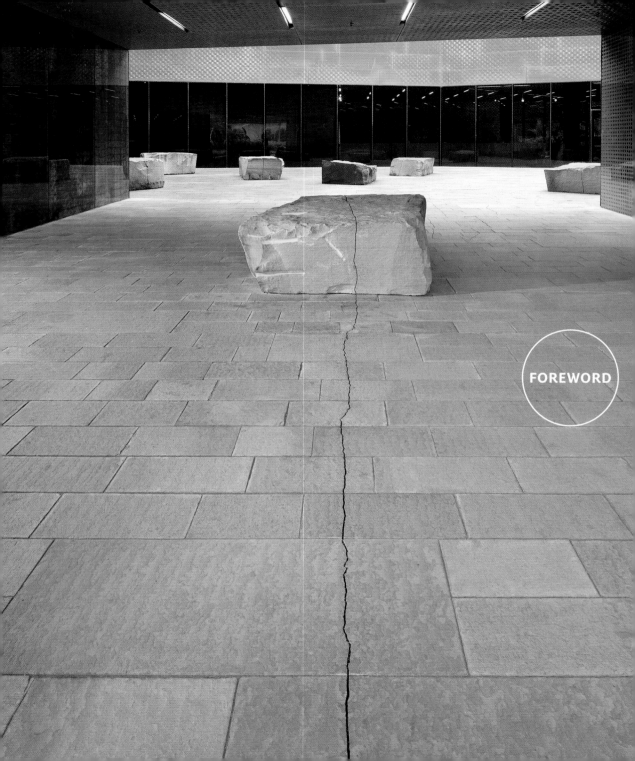

THE DE YOUNG, the city's oldest art museum, opened in 1895, having been completed a year earlier for the California Midwinter International Exposition. Its structure, which was replaced in the 1920s, sustained considerable damage over the years and was harmed beyond repair as a result of the 1989 Loma Prieta earthquake. I was privileged to lead the campaign that involved 7,014 donors who contributed to the rebuilding of the museum. The firm of Herzog & de Meuron was hired to bring this structure into the twenty-first century.

Today visitors of all ages are enchanted by the spacious galleries that hold our diverse permanent collections and feature world-famous special exhibitions, and our tower and sculpture garden, which are open to all visitors free of charge.

The de Young combines with the Legion of Honor to form the Fine Arts Museums of San Francisco, holding one of the largest memberships of any art museum in the United States. We are very proud of the ongoing support of our members and patrons, which attests to the importance they place on our mission to provide excellent exhibitions, educational programs, and conservation of the art entrusted to us.

More than one hundred years after their beginnings, the Fine Arts Museums continue to serve as one of the premier public arts institutions in the world. I am sure you will find the de Young as vibrant and beautiful as I do.

Diane B. Wilsey
President, Board of Trustees

Andy Goldsworthy's *Drawn Stone* (see pages 30–31) is the prominent feature of the museum's main entrance.

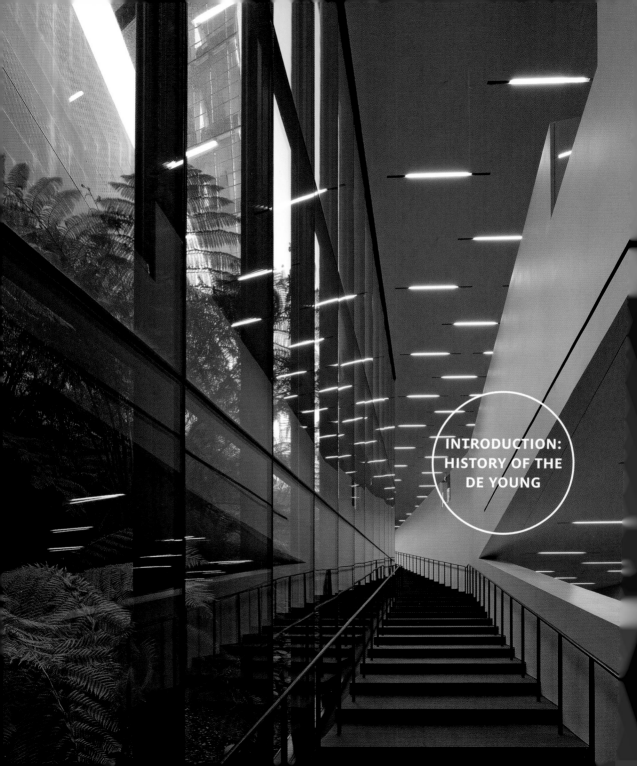

INTRODUCTION:
HISTORY OF THE
DE YOUNG

THE REMARKABLE MUSEUM STRUCTURE in Golden Gate Park was built just after the turn of the twenty-first century. Its origins, however, date back to the financial depression of 1893, when Michael H. de Young (1849–1925) (fig. 4) conceived of a world's fair, like the Columbian Exposition that he had recently attended in Chicago, to stimulate the economy in California. As the publisher of the *San Francisco Chronicle*, de Young held considerable power in the city, and he convinced the Park Commissioners that the California Midwinter International Exposition would be beneficial and could be mounted in less than six months.

There was some opposition to using Golden Gate Park as the location for the fair—many felt the park should be preserved as a refuge from the stresses of city life—so final approval stipulated that all buildings had to be temporary structures that could be removed within ninety days of closing.

The fair commissioners suggested creating "exotic" pavilions to prevent comparisons with the classical themes and white buildings of the Chicago exposition. Accordingly, the designers produced colorful fantasies ranging across Egyptian, Gothic, Mission, Moorish, Romanesque, and Spanish styles—a vision of "towers, minarets, domes, and castles," as it was described in the exposition's official history (see Sources and Further Reading, pages 106–107). The Fine Arts Building was designed by local architect Charles C. McDougall in the Egyptian Revival style (figs. I, 2), with a pyramid on its roof and images of Hathor, the Egyptian cow goddess and patron of dance and the arts, topping the massive entrance columns. Two sphinxes guarded the entry. De Young, who had been made director general of the fair, managed to get approval for a brick structure despite the call for temporary constructions. As early as June 1893 he had written into the Plan of Organization that

9

A staircase leading from the lower level to the main level reveals the lush Fern Court (see pages 60–63) behind a glass wall.

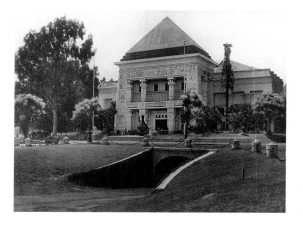

Fig. 1
The original Fine Arts Building
from the Midwinter Fair of
1894 was built in the Egyptian
Revival style.

10

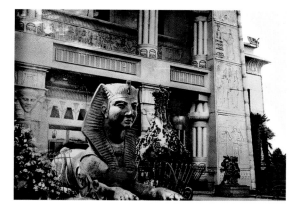

Fig. 2
The original sphinxes in front
of the Fine Arts Building were
replaced in 1910 with new
sphinxes by Arthur Putnam
(see page 29).

this edifice of "durable material" would be
"donated to the Golden Gate Park as a perma-
nent museum building."

On January 27, 1894, the exposition
opened to the public with an attendance of
72,248. By the time the Midwinter Fair, as it
became known, closed on July 4, 1894, a total
of 1,315,022 visitors had made it a financial
success. There had been no special funds to
begin the project. As the official history of the
fair reports, "Money from a Municipal source
was among the impossibilities." De Young's
initial gift of $5,000 to entice other private
support, much of which came from the work-
ing classes and people of moderate means,
helped create an event that resulted in surplus
funds. De Young wasted no time in begin-
ning to use those funds to build a general
museum collection "for the entertainment
and instruction of the people of California."
The executive committee of the fair, with
de Young at its head, offered the Fine Arts
Building to the Park Commissioners as a

Fig. 3
The Egyptian Revival influence
extended into the interior of
the Fine Arts Building, 1894.

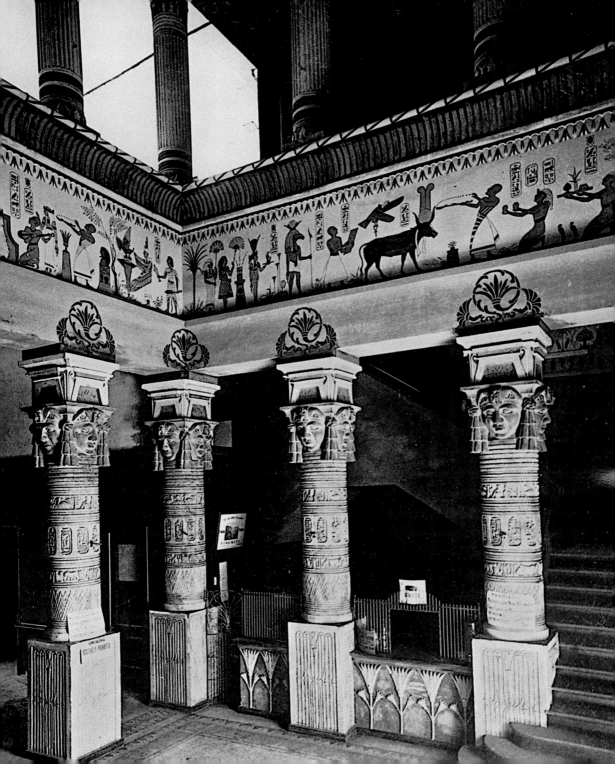

permanent museum to commemorate the
exposition, and the Royal Bavarian Pavilion
was moved nearby to provide additional
space for the collections. With the Park
Commissioners' acceptance of de Young's
plan, the newly named Memorial Museum
opened on March 25, 1895.

Charles P. Wilcomb was the first curator
of the new museum. He organized the exhibi-
tion of objects purchased from Midwinter
Fair exhibitors, as well as miscellaneous pieces
that de Young collected on trips to Europe.
Gustave Doré's eleven-foot-tall bronze vase
(fig. 5) was one work of lasting interest pur-
chased from the fair; it had first appeared in
this country at the Chicago exposition and,
through de Young's influence, was subse-
quently exhibited at the Midwinter Fair by the
French foundry that had produced it. Once
purchased, what has since become known as
the *Doré Vase* was placed outside the Memorial
Museum entry, between the two sphinxes.
These sphinxes were replaced by two new
concrete versions commissioned in 1910 from
the young sculptor Arthur Putnam; they have
since been restored and now stand in their
original positions in the park. The vase was
later moved inside the de Young, and then to
the Legion of Honor when the two museums

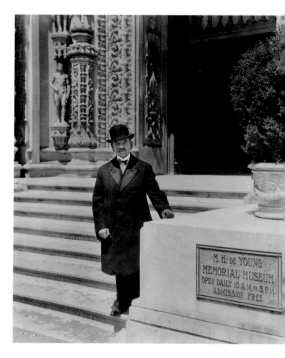

Fig. 4
Michael H. de Young stands
on the front steps of the
museum, which has been
named in his honor.

Fig. 5
Dancers surround the *Doré
Vase*, ca. 1926.

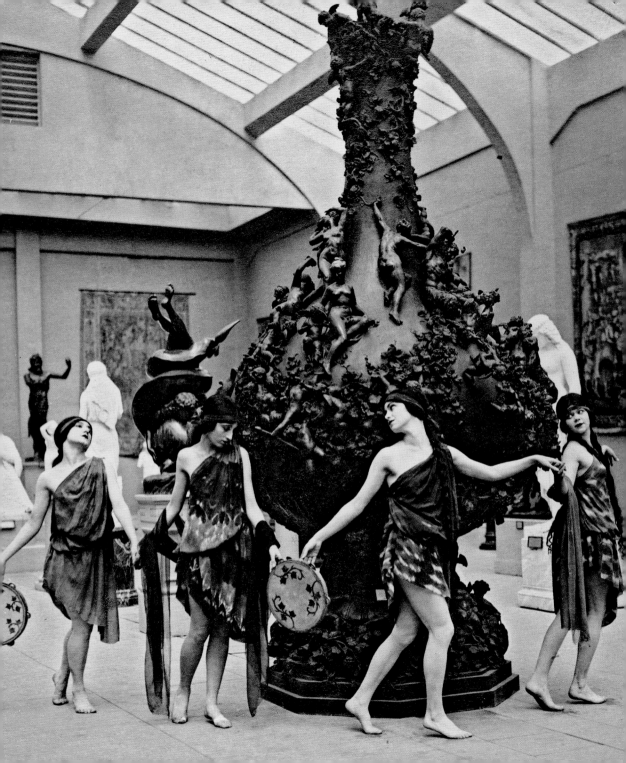

were joined. But today it once again stands outside, flanked by the Putnam sphinxes, adjacent to the new de Young (see page 29).

Though much of what de Young gathered for the museum could be classified as "curios," he did acquire a number of works from the Midwinter Fair that remain important parts of the collections: William Wetmore Story's monumental marble sculptures *Saul, the Israelite King* and *Dalilah*, as well as John Vanderlyn's painting *Caius Marius amid the Ruins of Carthage*, are foundations of the museum's holdings in American art. Important examples of ancient art and the arts of Africa, Oceania, and the Americas also entered the museum from the fair and these early collecting efforts. Wilcomb, an ethnographer and cultural historian, contributed objects from his personal collection as well. In addition to fine art, the museum displayed miscellaneous objects including art reproductions; suits of armor; furniture; Greek, Roman, and ancient American pottery; and even an Egyptian mummy, as well as a forestry exhibit and a natural history section.

Admission to the museum was free, and attendance swelled to more than half a million visitors in 1901. The collections continued to grow, but in 1906 the Great Earthquake did so much damage that the museum was forced

to close for a year and a half as repairs were made to both the building and the objects. By 1915, however, when the Panama-Pacific International Exposition (PPIE) brought masses of visitors to San Francisco, attendance at the Memorial Museum topped 700,000. Watching the growth of both the audience and the collections, de Young saw that the building needed to expand. As a member of the board of directors for the PPIE, he was well acquainted with the coordinator of its architecture, Louis Christian Mullgardt, and commissioned him to create a new museum adjacent to the original one. The structure was designed in the highly ornate Spanish Plateresque style (from the Spanish word *plata* for silver, and meaning "in the manner of a silversmith") (fig. 7) and constructed in two stages, the first of which was finished in 1919. In 1921, with the completion of the second stage, the Park Commissioners accepted the gift of the museum from de Young and gave it a new name, the M. H. de Young Memorial Museum. By a vote of the people in 1924 to amend the city charter, it became a city museum with a budget for its operation, maintenance, and superintendence. Establishment of the board of trustees was finalized on January 21, 1925; de Young died on February 15, leaving $150,000 to the museum.

14

Fig. 6
The Pool of Enchantment, designed by sculptor Melvin Earl Cummings, was finished in 1920. Today the new Pool of Enchantment, inspired by the original, stands in the Marcus Garden (see pages 28–29).

Fig. 7
The M. H. de Young Memorial
Museum was rebuilt in
1919 in the ornate Spanish
Plateresque style.

Meanwhile, the walls of the original
buildings were deteriorating, and they were
demolished in 1929. Within two years another
wing of the museum opened. By this time
many of the natural history objects were
declared unfit for exhibition and, with gifts
of art from William Randolph Hearst and
Samuel H. Kress, the collections began to be
focused more on fine art.

Expansion of the building came to a halt with the Great Depression, but the museum continued to evolve in other ways. Lloyd LaPage Rollins became the first director appointed by the board in 1931, and his duties included directorship of the California Palace of the Legion of Honor as well. In addition to refining the collections, he was also responsible for securing emergency repairs to the museum tower as some of the elaborate concrete decoration had begun to loosen and fall. In his short tenure he presided over the de Young's first recorded special exhibitions; prominent among them were displays of the photography of Imogen Cunningham and Margrethe Mather, as well as the Bay Area's Group *f*.64.

Rollins resigned in 1933 and German scholar Dr. Walter Heil (fig. 8) took over the position of director. Though his plans were much hampered by the Depression, in 1935 he managed to mount an exhibition of American paintings so large that it occupied both the de Young and the Legion of Honor. He also organized the extraordinary display of European masterpieces of painting and sculpture for the Golden Gate International Exposition (1939–1940) on Treasure Island. In negotiating the loans of these works, which

included Sandro Botticelli's *Birth of Venus*, Heil began to establish relationships with European museums that contributed to the development of the de Young's collections and programs, and that continue to this day.

World War II interrupted these international exchanges, and though the museum was visited by the thousands of servicepeople passing through San Francisco, the building continued to suffer from the neglect that had begun during the Great Depression. At one time a wooden shelter was built over the

Fig. 8
Dr. Walter Heil, director of the de Young from 1933 to 1961.

entrance to protect visitors from the debris of concrete ornaments that were falling off the building. By 1949 the museum had been stripped completely of its decoration and acquired the plain face that it wore for the next fifty years (fig. 9).

The refinement of the art collection was probably Heil's greatest contribution to the museum. He made important acquisitions, especially with the patronage of Roscoe and Margaret Oakes, and secured a fine selection from the Kress Collection gift, for which a new wing was added in the rear of the building in 1955, along with the eighteenth-century-French-style Oakes Garden Court. The exhibitions program also flourished, with shows of European and American art, including works by young local artists.

Heil retired in 1961, after almost thirty years spent guiding the museum into a new era. Though he was not personally very interested in modern art, he had given the curator of painting and sculpture, Ninfa Valvo, free rein to exhibit contemporary works. Her legacy is an impressive record of exhibitions of young artists, many of whom eventually rose to some prominence both locally and nationally—Morris Graves, John Saccaro, June Wayne, and Paul Wonner among them.

At about the time of Heil's retirement, Avery Brundage was seeking to place his collection of Asian art in a museum. Following negotiations by an enterprising group of San Franciscans, a bond issue to build a new west wing on the de Young to house the collection

Fig. 9
The museum acquired a plain face when it was stripped of its unsafe decorations in 1949.

18

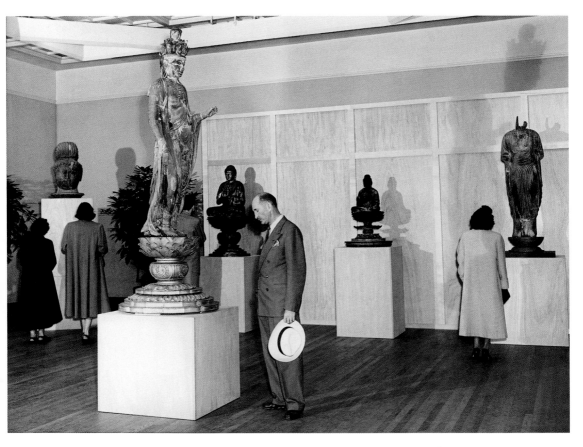

Fig. 10
Visitors view a Japanese art
exhibition in the de Young
galleries, 1951.

was placed on the city's 1960 ballot. It passed overwhelmingly, and the new wing opened in 1966. Heil's successor, Jack R. McGregor, was in charge of both the construction project and the management of the first half of the Brundage gift. But it soon became clear that Brundage wanted his collection to have its own management. In 1969 Mayor Joseph Alioto established the Center for Asian Art and Culture (which in 1973 would become the Asian Art Museum of San Francisco) as a separate museum with its own board and administration. Brundage then presented the second half of his gift to the city.

Housing two separate museums in one building, however, created a vagueness of identity and caused occasional tensions between the two administrations. This was further complicated by the formation in 1971 of the Museum Society, which combined the de Young's membership organization with the Legion of Honor's Patrons of Art and Music, and which in 1973 also began to support the Asian Art Museum. The joining of these three institutions through membership, though the latter was otherwise independent, created an ambiguity that was not clarified until the Asian Art Museum moved to its new home in the former San Francisco main library building in 2003.

When McGregor retired as director of the de Young in 1969, Ian McKibbin White, who had succeeded Thomas Carr Howe Jr. as director of the Legion of Honor, was asked to also step in as acting director of the de Young during its upcoming Van Gogh exhibition and as an experiment toward uniting the two museums. The following year White was officially made director of both institutions, and in 1972 a charter amendment placed them under one administration, making White the first director of the Fine Arts Museums of San Francisco. With the two museums joined, White established departments for the different areas of art and set up conservation laboratories to serve them.

White's primary focus was the growth of the collections, highlighted by several internal structural projects at the de Young. The establishment of the galleries for the arts of Africa, Oceania, and the Americas; the construction of new conservation labs; and improvements to public spaces such as the café signaled a maturing of the museum, its collections, and its administration. The renovated galleries of American art displayed paintings from the collection of Mr. and Mrs. John D. Rockefeller 3rd, which were given to the Fine Arts Museums beginning in 1979, and the Smithsonian Institution's Archives

20

of American Art (whose presence since 1973 had been instrumental in encouraging the Rockefeller gift) moved from a temporary space in the tower to a location next to the museum's library. The exhibition program also burgeoned. *The Treasures of Tutankhamun* set attendance records in 1979, as did *The Art of Louis Comfort Tiffany* in 1981 and *The New Painting: Impressionism 1874–1886* in 1986. The Fine Arts Museums of San Francisco became a notable presence among American arts institutions, originating and participating in international exhibitions with such museums as the Metropolitan Museum of Art in New York and the National Gallery in Washington, DC.

In 1987 White retired and Harry S. Parker III became director. Parker immediately reorganized the collections between the two museums, turning the Legion of Honor into the center for European and ancient art, and allowing the de Young to display a broader representation of art of the United States and from Africa, Oceania, and the Americas, as well as the textile collections. Unexpectedly, however, the defining moment of Parker's tenure came two years after he arrived. The Loma Prieta earthquake of 1989 interrupted everything, resulting in damages to both museums that required intensive repairs. The Legion of Honor underwent a major

expansion and renovation that was completed in 1995, but plans for the de Young evolved over a longer period of time.

At first it seemed that the building had suffered only minor harm, but a seismic evaluation in 1993 rated the hazard much higher. Steel bracing was installed on the exterior of the museum so that it could remain open to the public, but long and involved discussions swirled around the next step. Shortcomings of the structure had grown more noticeable, and it eventually became clear that replacement was inevitable. In 1995 the trustees voted for demolition, and the next year they added an underground parking facility to the plans for the new museum. However, a bond measure had already been planned for the November 1996 city ballot that would have authorized an amount of money to repair the existing structure; any additional funds for a new building and garage would have to come from private sources.

Unforeseen opposition to the underground garage threw a wrench in the plans. In an echo of the resistance M. H. de Young had faced when he first suggested Golden Gate Park as the location for the Midwinter Fair, various special interest groups began to question the idea of continuing to have a museum in the park at all. The bond measure

of 1996 lost, though only by a small margin. Confronted with this defeat, the museum began to consider abandoning the park for a downtown location. As that idea took shape, however, new groups emerged to defend staying in the park, and fears of adding to congestion at the proposed site near the Embarcadero supported their cause.

The situation grew worse in 1997 when the museum learned it could no longer secure federal indemnification for traveling exhibitions, as the bracing of the building was deemed inadequate for the safety of artworks on loan. After more meetings and public discussions, a poll of citizens found that close to eighty percent wanted the museum to remain in Golden Gate Park. The trustees then voted to keep the present location, and a new bond measure, which did not include the garage, was put on the ballot. Dogged by new problems having more to do with property taxes and tenants' rights than with museum issues, the measure failed again.

At this point board president Diane B. Wilsey, known as Dede, decided the museum should take a different approach and raise the funds privately. In October 1998 the board voted to construct a new building without any public funds. This presented new challenges: not only to gather the money, an effort Wilsey

spearheaded, but also to identify the best architectural firm for the project.

As the international search began, twenty-five firms made submissions. The field narrowed to six after technical review, and by January 1999 the selection committee of donors and trustees made their choice. The young Swiss firm of Herzog & de Meuron had been the only architects to focus in their interviews on the museum's collections and how to best present them in a new context. They had also expressed willingness to participate in the extended public process of architectural design required by the city of San Francisco for a museum in a city park. That, and their reputation for a guiding interest in finding new solutions for their clients, confirmed them as the best choice in the eyes of the committee. The San Francisco office of Fong & Chan Architects would execute the design and oversee engineering and construction issues, as well as code compliance and material specifications.

By June 1999 the initial design concept was ready and presented to the public. Though it was praised by architecture critics, a number of its features soon fell subject to criticism: it was too rectilinear, the tower was too tall, details of the materials to be used were not clear. Over the next two

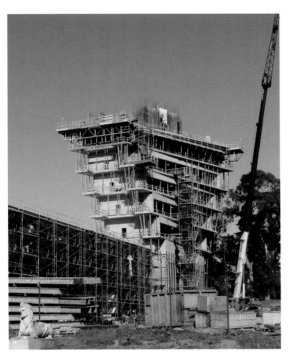

Fig. 11
Construction of the new
de Young, seen here in 2004,
presented a challenge with its
twisting tower.

The most daring feature of the new
de Young may be its copper covering. For
three years the discussions of materials for the
cladding of the building centered on redwood
siding, copper, and glass. But the architects
soon suggested something more adventur-
ous—copper wire mesh. Though the wire
had an appealing visual softness, some critics
likened it to chain-link fencing. Herzog & de
Meuron continued to experiment and finally
arrived at copper paneling, pierced and dim-
pled in patterns derived from pixilated digital
photographs of the foliage in the park. The
museum's project director, Deborah Frieden,
conducted an international search to find a
firm to manufacture the panels. She selected
A. Zahner Company in Kansas City, a highly
respected family firm that provided each of
the 7,200 individually patterned and shaped
panels from a total of 950,000 pounds of
copper. The new de Young would become the
largest copper-clad building in the world.

23

years plans moved through the public pro-
cess, the Environmental Impact Report,
and the requirements of the City Planning
Department. The tower was shortened; and
the Pool of Enchantment, sphinxes, and
palm trees that represented vestiges of earlier
museum incarnations were all to be incorpo-
rated into the new design. At last, in January
2002, the San Francisco Board of Supervisors
approved the project, and demolition of the
old buildings began in the spring.

Of paramount importance was making the building seismically safe. Fong & Chan worked with structural engineers Rutherford & Chekene to secure a base-isolation system that would allow the foundation of the museum to move independently in an earthquake, preventing transmission of the vibrations to the building. Construction of the copper roof was another problem: because it would be visible from the tower as another facade, most of the mechanical details would have to be "hidden" inside the building. But ensuring the safety of the tower, which rises and twists into a parallelogram at the top, presented the greatest challenge. The solution, which had to be approved by the Fire Department, was to move the stairway to the exterior, behind the perforated copper panels, resulting in both safety and elegance.

The new de Young opened in October 2005 (fig. 12). The stunning building is both in the park and of the park. Inside, two glass-walled "outdoor" spaces, the Fern and Eucalyptus Courts, open to the sky. Outside, the Barbro Osher Sculpture Garden to the west, the Marcus Garden of Enchantment to the east, the expanse of grass and palm trees in front, and the landscaping behind—all part of landscape architect Walter Hood's design—encircle the building and link it to the park.

The museum displays both new and previously acquired holdings in novel and refreshing ways: an important expansion of the collection of New Guinea art dominates the western side of the second floor, and international works of contemporary art have entered the collections both inside and in the open-air sculpture garden.

In another echo of the Midwinter Fair, whose private funding generated the surplus from which the de Young originated, Wilsey's campaign for private monies for the building project succeeded in raising considerably more than the originally projected $165 million. Parker not only participated in the fund-raising and oversaw the new building project, but also directed the continuing exhibition program, which focused on the Legion of Honor during the construction of the de Young. The monumental exhibition *Hatshepsut: From Queen to Pharaoh* inaugurated the new temporary exhibition galleries when the museum reopened. For Parker, this was the culmination of a term at the Fine Arts Museums that had held both unforeseen challenges and hard-won successes.

Parker retired in December 2005, and John E. Buchanan, Jr., became director in February 2006. Until his untimely death at the end of 2011, Buchanan presided over an

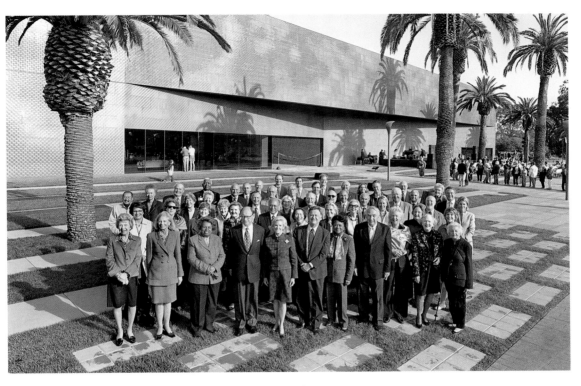

active and well-attended group of traveling
exhibitions. Another period of economic
downturn affected the country during those
years, but his exhibition program helped keep
the Fine Arts Museums fiscally stable. At the
de Young, extraordinary attendance centered
first on an exhibition of Dale Chihuly glass
and then marked, among others, two exhibi-
tions of Impressionist and Post-Impressionist
paintings from the Musée d'Orsay in Paris,

Fig. 12
Museum trustees, with
Diane Wilsey at center, along-
side Harry Parker, gather
to celebrate the opening
of the new de Young in
October 2005.

Fig. 13
The de Young structure today
has been built for a new
century but echoes many of
its previous characteristics,
including a tower.

26

displays of haute couture from designers
such as Yves Saint Laurent and Cristóbal
Balenciaga, and—thirty years after the origi-
nal "King Tut" exhibition—the return of the
treasures of King Tutankhamun for a new
generation to discover. Buchanan saw the
opening of *Masters of Venice: Renaissance Painters
of Passion and Power* and provided plans for a
vigorous exhibition schedule to follow. All
of these presentations and others since have
been accompanied by a bold roster of public
programs that aim to reach new audiences
and make the museum a true partner in San
Francisco's vibrant artistic community.

The new de Young is an architectural
monument in a city that has traditionally
resisted daring statements in public struc-
tures. The life of the museum founded by
M. H. de Young in 1895 now thrives in a
building that signals its importance in the
twenty-first-century art world.

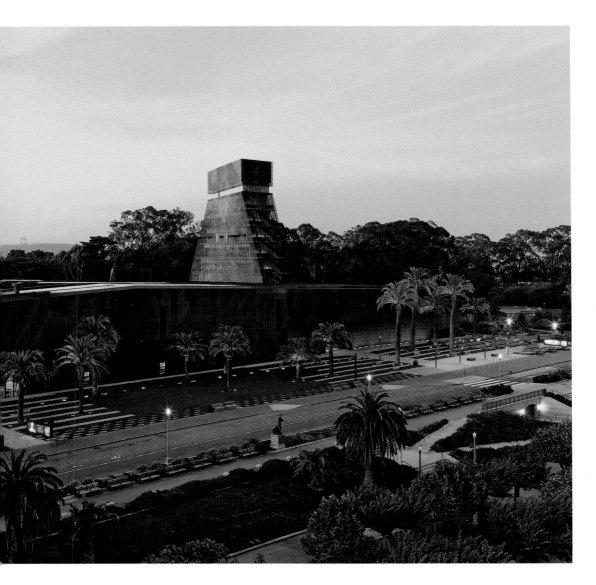

GEORGE AND JUDY MARCUS
GARDEN OF ENCHANTMENT

among the boulders and grasses on the central island. Even the water lilies have been reinstated, along with new rocks for sunning turtles.

Further paths lead around hillocks and trellised seating areas where small animal sculptures by Arthur Putnam perch in their protective cages. Putnam's bronze *Cave Man* and Albert Laessle's *Penguins* surprise visitors at one corner of the garden. Occasionally a fog field throws mist into the air along one of the paths for children to run through— a playful reminder of the weather patterns characteristic of this part of the city—and a wide variety of plants and outdoor room- like spaces create an environment to stimulate young imaginations.

THE GARDEN OF ENCHANTMENT, also known as the Children's Garden, greets visitors from the walkway in front of the museum, along the Concourse. The sphinxes (right) and the *Doré Vase* (above) that sat in front of the original Egyptian Revival Fine Arts Building around the turn of the twentieth century now are at the edge of the eastern walkway. Behind them is another element from the past—the Pool of Enchantment, an echo of the pool that welcomed visitors to the old de Young. The new incarnation is circular, but the previous pool's sculptures of two pumas and a boy playing a flute, by Melvin Earl Cummings, once again appear

HELEN DILLER FAMILY COURTYARD
ANDY GOLDSWORTHY'S
DRAWN STONE

THE APPLETON GREENMORE sandstone pavers that surround the museum come from Yorkshire, England, not far from the birthplace of British sculptor and environmentalist Andy Goldsworthy. Commissioned to make an original work for the de Young's 2005 reopening, Goldsworthy responded to the fact that the museum was built "in defiance of earthquakes" on base-isolation shock absorbers and created a simulated fault line that runs from the roadway in front of the building through the entry court and its eight boulders. He views his "drawing" in the stone as a reminder of nature's dominance. Thus the seemingly natural line that cleaves even the boulders is actually a product of Goldsworthy's laborious efforts to split each stone and match the breaks so that it all appears to be the result of one spontaneous seismic event.

DIANE B. WILSEY AND
ALFRED S. WILSEY COURT

PEOPLE OFTEN REFER TO Wilsey Court as the heart of the museum, where many begin their visit or gather for special events. The expansive space is uncluttered by structural columns, and a grand staircase leads to the second-floor galleries. Views into the Fern and Eucalyptus Courts add to the openness of this area, which becomes a bustling town square on Friday evenings when the museum stays open for extended hours to present a variety of entertainment and educational programs related to its collection and exhibitions.

Gerhard Richter's *Strontium* (2004) commands the western wall of Wilsey Court. A gift to the Fine Arts Museums from board president Diane B. Wilsey in memory of her late husband, Alfred S. Wilsey, upon the opening of the new de Young, *Strontium* is one of the largest and most significant works by this influential artist. Born in Dresden, Germany, in 1932, Richter lives and works in Cologne and has recently found inspiration in the role of molecular science in our daily lives. *Strontium* is composed of 130 C-print photographs mounted on aluminum and joined to form a mural measuring roughly thirty-one by thirty feet. Digital manipulation of the images, which were drawn from a newspaper reproduction of a structure of strontium titanate, creates a halo effect such that the pictures become increasingly blurred as the viewer approaches. Within its organizing grid this optical artwork challenges the viewer and transforms the room. During Friday Nights at the de Young, musical performances and colored lights often interact with this arresting piece in the social hub of the museum.

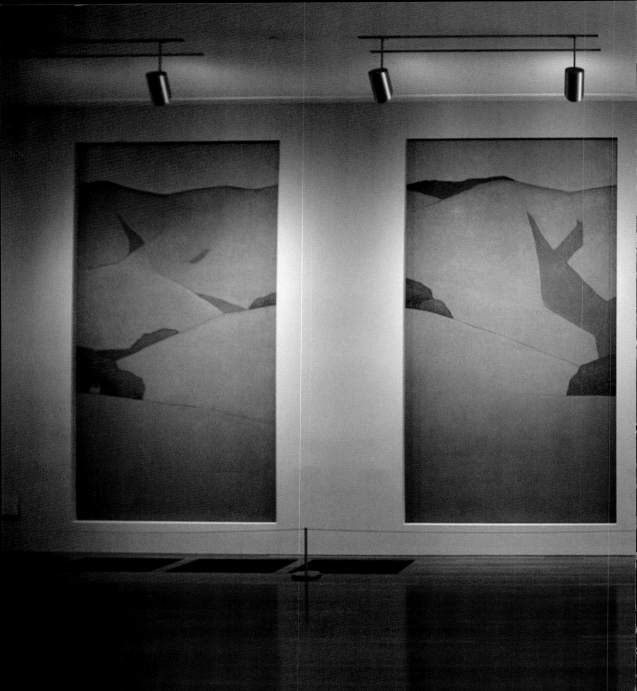

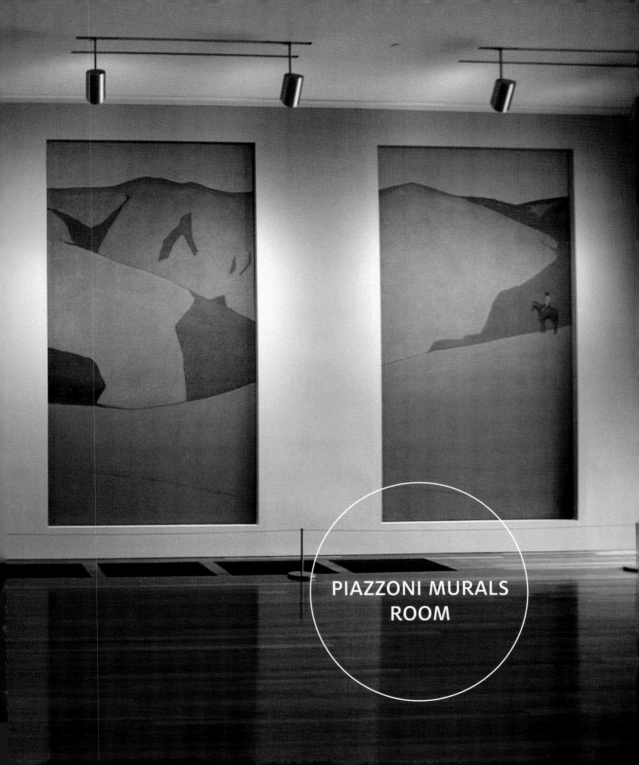

PIAZZONI MURALS
ROOM

GOTTARDO PIAZZONI created these two murals, *The Sea* and *The Land*, in 1931–1932 for the loggia of San Francisco's old main library (now the Asian Art Museum) (see page 69). The Swiss-born Piazzoni came to California at the age of fifteen and studied from 1891 to 1893 at what is now the San Francisco Art Institute. He then went to Paris to study at the Académie Julian and the École des Beaux-Arts. Influenced by such artists as James McNeill Whistler and Pierre Puvis de Chavannes,

whose work he had seen in Europe, as well as by Asian art, he painted canvases that were unusually minimalist and modern for their time. The murals created for the library, which had opened in 1917, were innovative and exceptionally abstract compared to the work of Piazzoni's California contemporaries, and they were an integral part of the building.

In 1994, however, a new library was planned and the old building was set to be refurbished to house the Asian Art Museum. Neither the

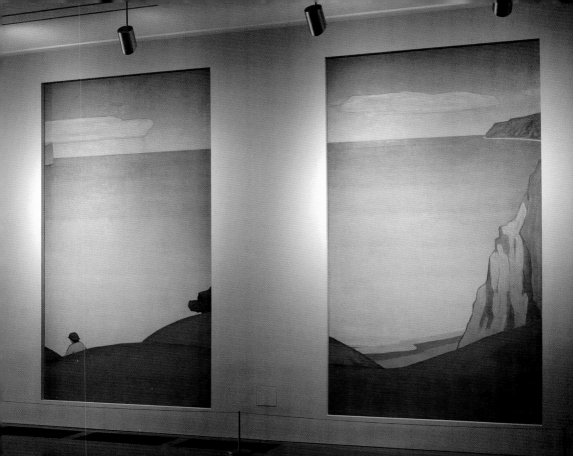

renovating architect, Gae Aulenti, nor the Asian Art Museum administration saw a place for the murals in the repurposed building, and the issue of their new home became a center of controversy. In 1999, after much discussion among art historians, museum curators and administrators, and city officials, a city arts committee recommended that the murals be moved to the new de Young, which was then only in the planning stages.

The canvas-backed murals were removed from the old library, and the Asian Art Museum financed their conservation in preparation for their reinstallation. Though the artworks were site-specific creations for their original location, they fit comfortably in the new space specially designed for them at the de Young. Their serene beauty, which can be viewed much more easily now, transforms an otherwise unadorned room in the museum.

American Art

HOME TO MORE THAN one thousand paintings, six hundred sculptures, and three thousand decorative art objects made in the United States from the late seventeenth century to the present day, the de Young offers visitors the most comprehensive museum survey of American art in the American West, and one of the top ten nationally.

American art objects were part of the founding collections of both the de Young and the Legion of Honor. In the 1930s, when these works were not widely valued, the de Young exhibited more than four hundred American paintings, paving the way for its later emphasis in this area. When the two museums merged in 1972, their holdings of American art were combined and reorganized at the de Young to form a stronger and more significant overview.

Central to the collection's growth was a remarkable gift from Mr. and Mrs. John D. Rockefeller 3rd. Acquired by the Fine Arts Museums between 1979 and 1993, this donation included more than one hundred American paintings spanning the colonial period to the twentieth century. Since then the de Young has expanded its exhibition space for American art and made a concerted effort to augment the collection by acquiring works by notable modern and contemporary artists.

The American galleries integrate paintings, sculpture, and decorative arts in an essentially chronological installation that spans a wide range of artistic periods and styles, dating from the precolonial era to the present. Of particular depth in the collection is artwork by internationally recognized artists based in California, such as Richard Diebenkorn (page 45) and Wayne Thiebaud, as well as artists who worked here for significant but shorter periods of time, including Albert Bierstadt (left) and Masami Teraoka. A permanent installation in the lobby of the museum's tower highlights sculptures by the San Francisco artist Ruth Asawa (see pages 96–97).

In 1973 the de Young became host to the West Coast Regional Center of the Archives of American Art, a bureau of the Smithsonian Institution. The museum's American Art Department has continued to administer access to its microfilm collection since the center closed in 1991. With that resource alongside the Bothin Library and the American Art Department research files, the de Young houses the most important research center for American art on the West Coast.

40

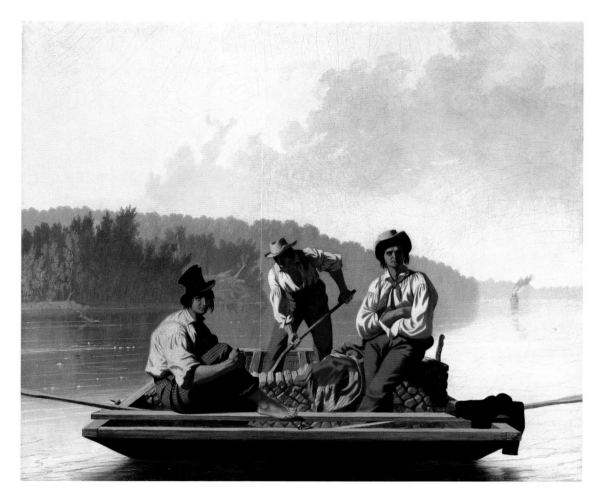

George Caleb Bingham (American, 1811–1879)
Boatmen on the Missouri, 1846
Oil on canvas
25 ⅛ x 30 ¼ in. (63.8 x 76.8 cm)

Gift of Mr. and Mrs. John D. Rockefeller 3rd, 1979.7.15

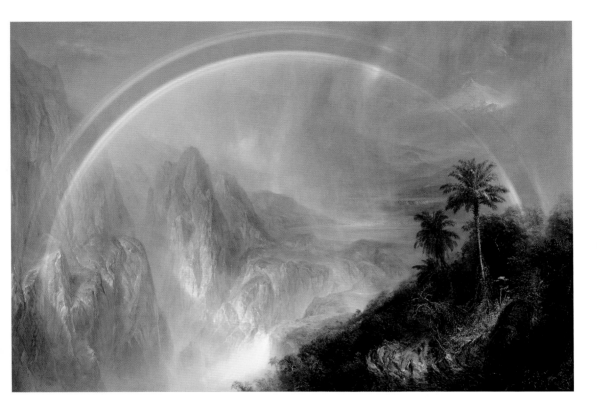

Frederic Edwin Church (American, 1826–1900)
Rainy Season in the Tropics, 1866
Oil on canvas
56 ¹/₄ x 84 ¹/₄ in. (142.9 x 214 cm)

Museum purchase, Mildred Anna Williams Collection, 1970.9

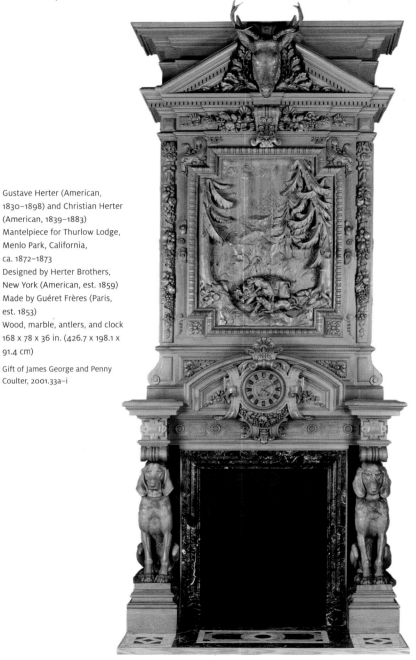

Gustave Herter (American, 1830–1898) and Christian Herter (American, 1839–1883)
Mantelpiece for Thurlow Lodge, Menlo Park, California, ca. 1872–1873
Designed by Herter Brothers, New York (American, est. 1859)
Made by Guéret Frères (Paris, est. 1853)
Wood, marble, antlers, and clock
168 x 78 x 36 in. (426.7 x 198.1 x 91.4 cm)

Gift of James George and Penny Coulter, 2001.33a–i

42

Right: Aaron Douglas (American, 1899–1979)
Aspiration, 1936
Oil on canvas
60 x 60 in. (152.4 x 152.4 cm)

Museum purchase, the estate of Thurlow E. Tibbs Jr., the Museum Society Auxiliary, American Art Trust Fund, Unrestricted Art Trust Fund, partial gift of Dr. Ernest A. Bates, Sharon Bell, Jo-Ann Beverly, Barbara Carleton, Dr. and Mrs. Arthur H. Coleman, Dr. and Mrs. Coyness Ennix Jr., Nicole Y. Ennix, Mr. and Mrs. Gary Francois, Dennis L. Franklin, Mr. and Mrs. Maxwell C. Gillette, Mr. and Mrs. Richard Goodyear, Zuretti L. Goosby, Marion E. Greene, Mrs. Vivian S. W. Hambrick, Laurie Gibbs Harris, Arlene Hollis, Louis A. and Letha Jeanpierre, Daniel and Jackie Johnson Jr., Stephen L. Johnson, Mr. and Mrs. Arthur Lathan, Lewis & Ribbs Mortuary Garden Chapel, Mr. and Mrs. Gary Love, Glenn R. Nance, Mr. and Mrs. Harry S. Parker III, Mr. and Mrs. Carr T. Preston, Fannie Preston, Pamela R. Ransom, Dr. and Mrs. Benjamin F. Reed, San Francisco Black Chamber of Commerce, San Francisco Chapter of Links, Inc., San Francisco Chapter of the NAACP, Sigma Pi Phi Fraternity, Dr. Ella Mae Simmons, Mr. Calvin R. Swinson, Joseph B. Williams, Mr. and Mrs. Alfred S. Wilsey, and the people of the Bay Area, 1997.84

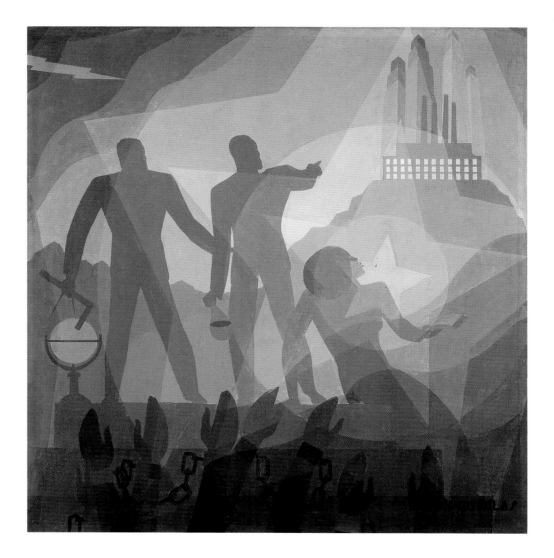

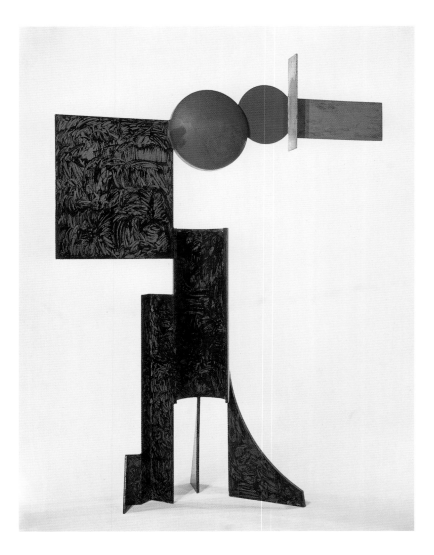

David Smith (American, 1906–1965)
Zig V, 1961
Steel and automotive paint
111 x 85 x 44 in. (281.9 x 215.9 x
111.8 cm)

Museum purchase, gift of Mrs. Paul L.
Wattis, 1999.66

Art © Estate of David Smith / Licensed by
VAGA, New York, NY

44

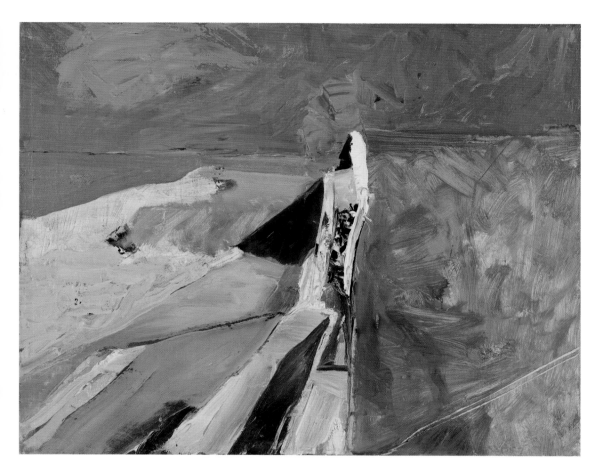

Richard Diebenkorn (American,
1922–1993)
Seawall, 1957
Oil on canvas
20 x 26 in. (50.8 x 66 cm)
Gift of Phyllis G. Diebenkorn,
1995.96

BARBRO OSHER
SCULPTURE GARDEN

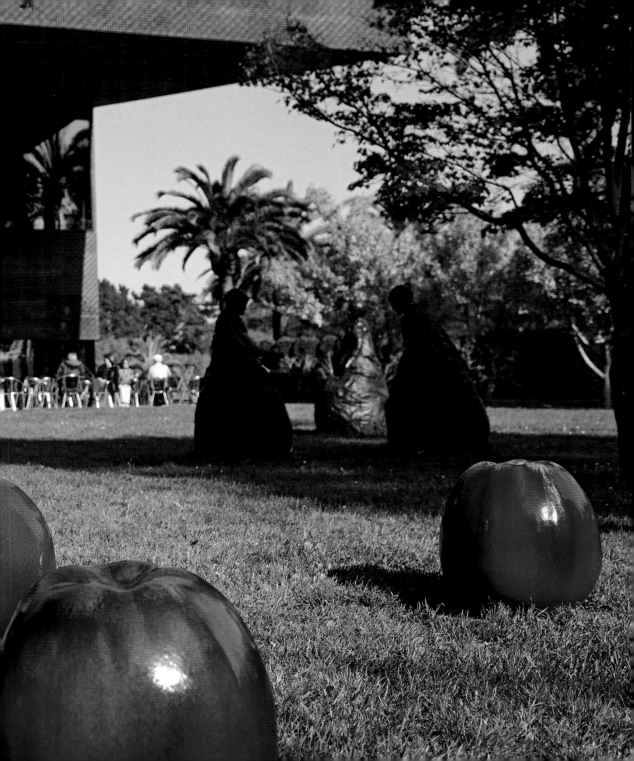

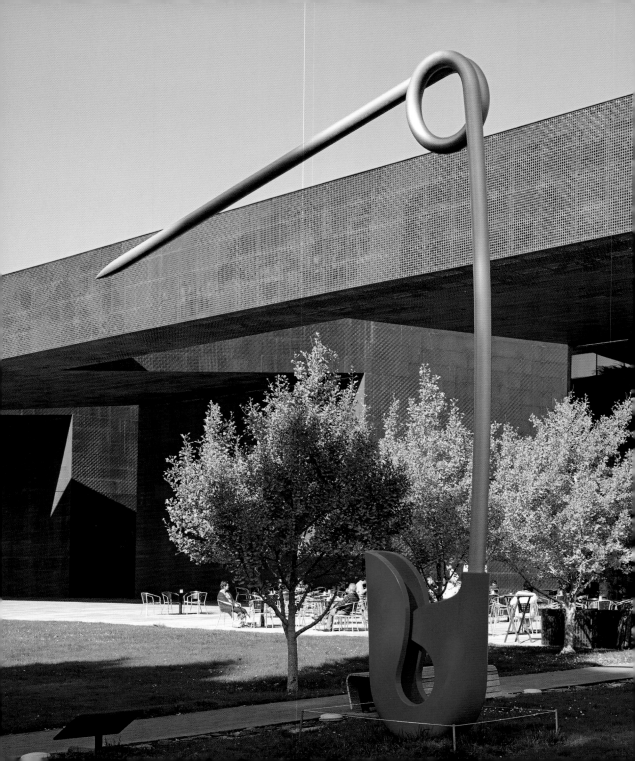

EXTENDING FROM THE CAFÉ TERRACE
under the cantilevered roof on the western side of
the museum, the Barbro Osher Sculpture Garden
forms a visual link with the adjacent Japanese Tea
Garden. The Tea Garden was created by landscape
architect Makoto Hagiwara after the 1894 California
Midwinter International Exposition, on the site of
its "Japanese Village"; more than a hundred years
later the museum's landscape architect, Walter
Hood, provided a new view onto that space with
the Sculpture Garden, integrating these two ele-
ments of the park and honoring the history of the
location. The Sculpture Garden's plantings comple-
ment and merge with the maples and cherry trees
in the Tea Garden to provide a seasonally changing
panorama from the terrace.

Although sculptures occasionally rotate in and
out of view, many installations are situated for the
long term. Barbara Hepworth's *Pierced Monolith
with Colour* (right) is the first work encountered as
you leave the building and enter the terrace. To
the right is Zhan Wang's gleaming stainless steel
Artificial Rock (see page 57), as well as the path
to James Turrell's domed "skyspace," *Three Gems*
(see pages 50–51). To the far left, on the opposite
side of the garden, stands Claes Oldenburg and
Coosje van Bruggen's *Corridor Pin, Blue* (left), a
giant upended safety pin that disorients viewers
rather than fastening
things together.
The path
encircling
the garden
leads past
works
by Isamu
Noguchi,
Stephen De
Staebler, Robert

Arneson, Beverly Pepper, and Joel Shapiro. The
repertoire of international sculptors continues into
the garden's grassy center. There works by Louise
Nevelson, Henry Moore, and Arnaldo Pomodoro
share space with Gustav Kraitz's twelve *Apples*
and the trio of forms that compose Juan Muñoz's
Conversation Piece V (Three Figures) (see pages
46–47). The museum's youngest visitors find these
works and Joan Miró's *La Maternité* irresistible; the
relaxed space expands the museum experience for
both adults and the children who play on the grass
around the sculptures.

JAMES TURRELL'S
THREE GEMS

IN THE NORTHWEST CORNER of the Osher
Sculpture Garden is James Turrell's *Three Gems.* Of
the several "skyspaces" built by Turrell since the
1970s, this is the first to take the mound shape of
a stupa, a monument that traditionally serves as
a Buddhist shrine. The external evidence of this
piece is subtle—a grass-covered dome that was a
part of landscape architect Walter Hood's design
for the garden. Access to the interior can be gained
through a tunnel leading to a cylindrical open space
with terracotta-colored plaster walls that surrounds
a white plaster dome.

From there, a door in the dome lets visitors
enter a viewing chamber with a circular opening,
an oculus, cut into the roof. Along the walls is a
bench where they may sit to contemplate the sky
and experience the shifting effects of light and
shadow as the sun's position changes or clouds or
fog drift across the oculus. A hidden system of neon
lights contributes to visitors' altered perceptions of
these transformations. Turrell has created a unique
space for experiencing the nature of light through
a focused frame of reference, free of outside visual
and aural stimuli.

Contemporary
Art

IN RECENT DECADES the Fine Arts Museums have strengthened their commitment to collecting contemporary pieces by American and international artists, acquiring paintings, sculptures, and works in nontraditional formats including installation, conceptual and video art.

For the opening of the new de Young in 2005 the Museums commissioned several important pieces including *Near* (detail left), by Kiki Smith, which is suspended from the ceiling of the Saxe Gallery, and the site-specific works *Drawn Stone* by Andy Goldsworthy, in the Helen Diller Family Courtyard (see pages 30–31), and *Three Gems* by James Turrell, in the Barbro Osher Sculpture Garden (see pages 50–51), where additional contemporary works are installed (see pages 46–49).

A truly international collection, the de Young's contemporary holdings feature many foreign-born artists such as Sean Scully (page 58), Cornelia Parker (page 59), Gottfried Helnwein, Doris Salcedo, David Nash, and El Anatsui (see page 77). Works in lens- and time-based media represent a new area of growth; these holdings include pieces by Nigel Poor and Rebeca Bollinger.

Contemporary studio craft objects are displayed in a gallery named for Dorothy and George Saxe, highlighting the significance of these collectors and the works they have given or pledged to the Fine Arts Museums. Comprising more than five hundred objects, the Saxe Collection, which includes mixed-media works by artists such as Josiah McElheny (page 56), has transformed the de Young into one of the most important repositories for contemporary studio craft in the United States.

54

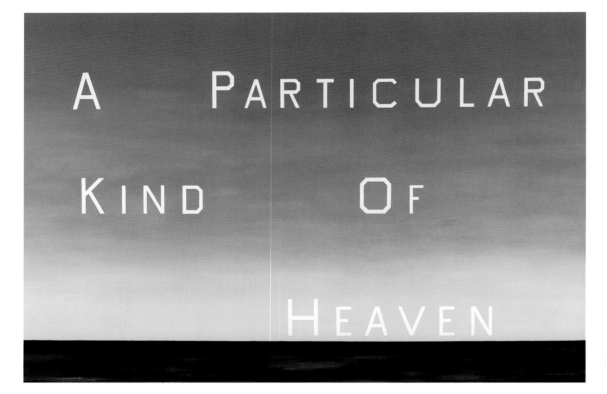

Ed Ruscha (American, b. 1937)
A Particular Kind of Heaven, 1983
Oil on canvas
90 x 136 ½ in. (228.6 x 346.7 cm)

Museum purchase, Mrs. Paul L. Wattis
Fund, 2001.85

Carl Andre (American, b. 1935)
Voltaglyph 36, 1997
36 copper and zinc plates
$^{5}/_{16}$ x 59 x 59 in. (0.8 x 149.9 x 149.9 cm)

Museum purchase, gift of the Friends of New Art in memory of John E. Buchanan, Jr., 2012.2

55

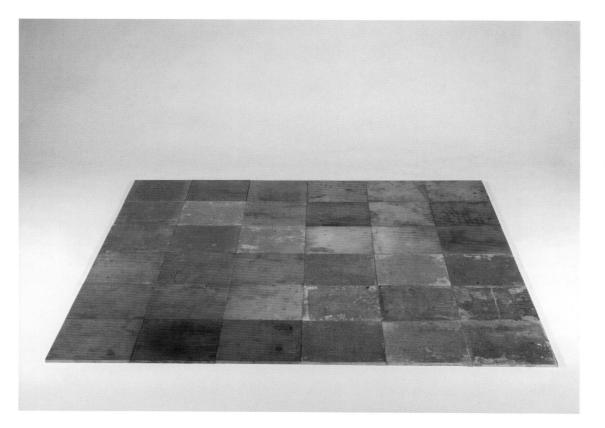

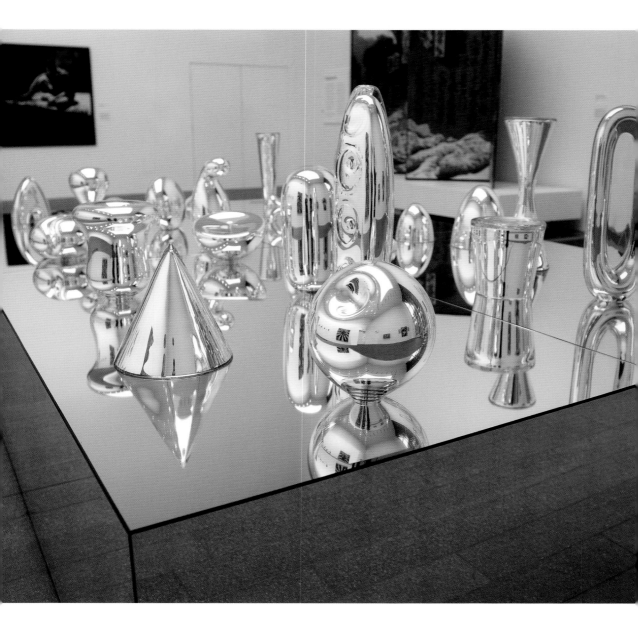

Left: Josiah McElheny (American, b. 1966)
Model for Total Reflective Abstraction (after Buckminster Fuller and Isamu Noguchi), 2003
Blown glass, mirrored float glass, and wood
48 x 144 x 88 in. (121.9 x 365.8 x 223.5 cm)

Gift of Dorothy and George Saxe to the Fine Arts Museums Foundation, 2005.163.53

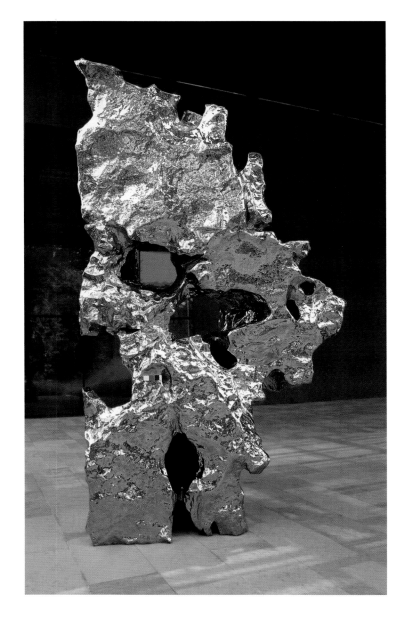

57

Right: Zhan Wang (Chinese, b. 1962)
Artificial Rock, 2005
Stainless steel
177 ¹/₈ x 78 ³/₄ x 94 ¹/₂ in. (449.9 x 200 x 240 cm)

Foundation purchase, a gift from Dagmar Dolby in celebration of Ray Dolby's 1965 founding of Dolby Laboratories, 2005.61

Sean Scully (American, b. 1945)
Wall of Light Horizon, 2005
Oil on canvas
96 x 144 in. (243.8 x 365.8 cm)

Museum purchase, gift of Nan Tucker
McEvoy, 2007.2a–b

Right: Cornelia Parker (English,
b. 1956)
Anti-Mass, 2005
Charcoal retrieved from a church
destroyed by arson, Alabama USA
156 x 132 x 135 in. (396.2 x 335.3 x
342.9 cm)

Museum purchase, Friends of New Art,
and American Art Trust Fund, in honor
of Harry S. Parker III and Steven A.
Nash, 2006.2

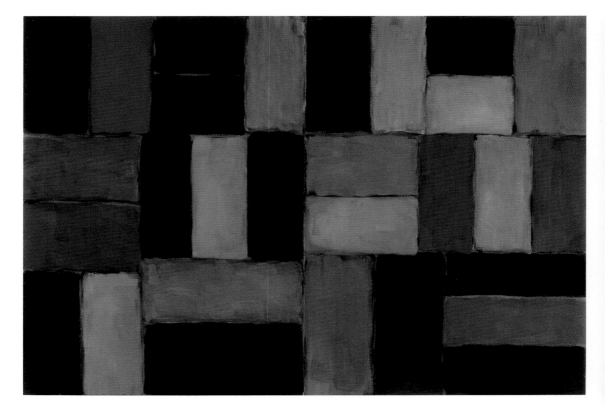

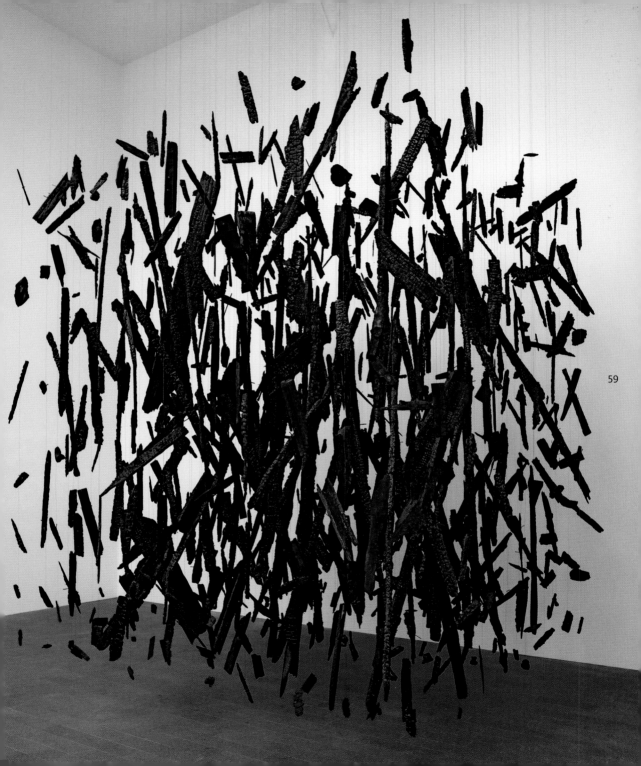

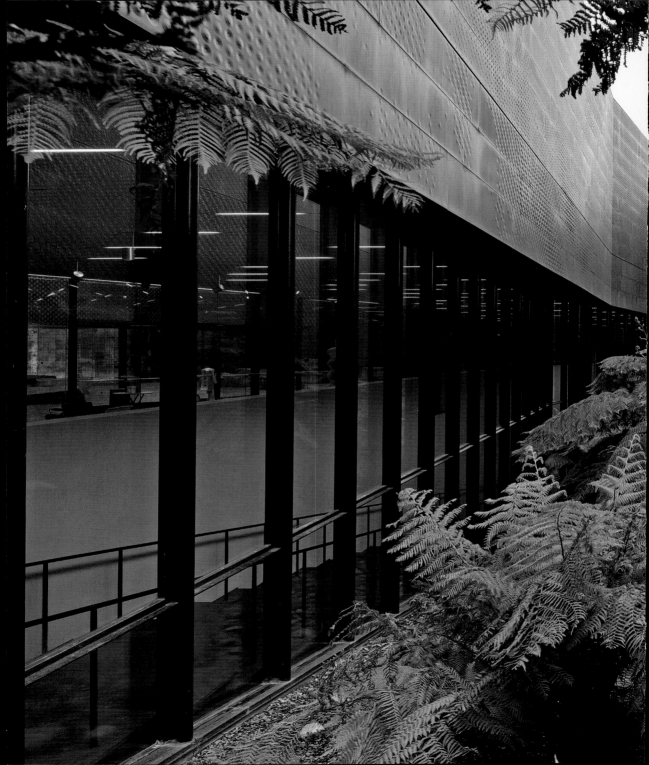

FERN AND
EUCALYPTUS
COURTS

NATURE NOT ONLY surrounds the de Young but also enters the museum, with two narrow garden courts that align east to west through the building. The Fern Court offers a visual extension of the Marcus Garden of Enchantment on the eastern side and can be seen through the glass wall beside the stairs that rise in two directions from the lower floor of the museum. The Eucalyptus Court greets visitors atop the stairs and alongside the galleries, offering a reminder that the park is not far away.

Their designer, landscape architect Walter Hood, has referred to these spaces as "large-scale terrariums," though they are not fully enclosed. Birds have found their way into the courts, which are open to the sky, and hummingbirds occasionally build nests on the branches of the trees.

The gardens are visible from central departure points to the galleries on both the main and second floors, orienting visitors as they move through the different areas of the collections. These incursions create an interior environment that is harmonious with the surrounding nature, reminding museumgoers that they are in a park even as they explore the galleries.

A hummingbird makes its nest in a eucalyptus (above). The Eucalyptus Court (right) brings a view of the park into the museum galleries.

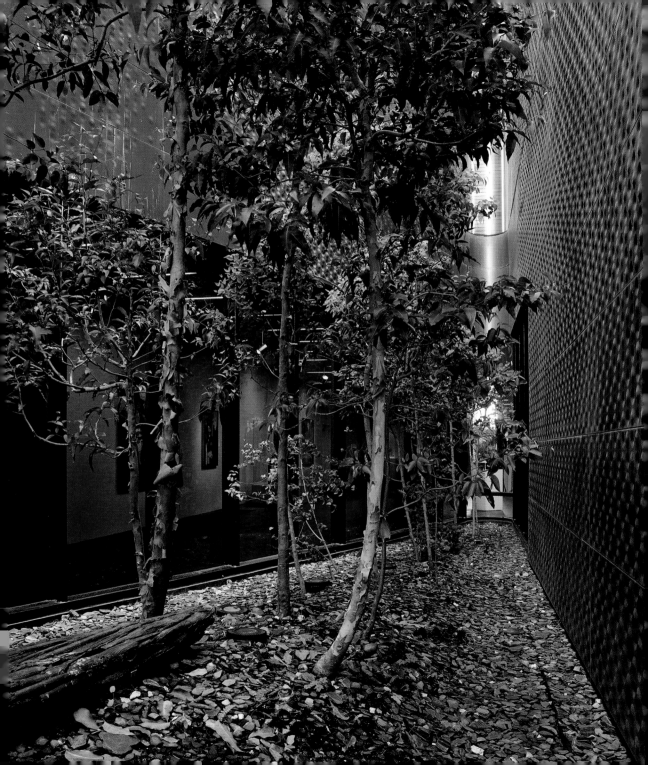

Photography

THE PHOTOGRAPHY COLLECTION of the Fine Arts Museums of San Francisco spans the entire history of the medium, with particular strength in its nineteenth-century American and European holdings. Photographers represented in depth include Eadweard Muybridge (left), David Seymour (Chim), Imogen Cunningham (page 68), John Gutmann, Arthur Siegel, Bill Owens, and Ed Ruscha.

The de Young began accepting photographs into its collection during its earliest years, starting with documentary scenes of the California Midwinter International Exposition of 1894. Its holdings eventually grew to encompass a large concentration of historical California photographs, with many views of the Bay Area and daguerreotype portraits of its citizens. In 1932 the museum hosted the first exhibition of works by a group of San Francisco photographers known as *f*.64, which included Cunningham, Ansel Adams (page 69), Edward Weston, and other artists who are now widely celebrated and represented in the permanent collection.

Like the de Young, the Legion of Honor amassed a large number of historical photographs before the museums merged. Its most important acquisition in this area was a 1943 purchase of negatives and prints by Arnold Genthe that depict San Francisco in the immediate aftermath of the 1906 earthquake (see page 66). After the museums came together in 1972, the photography collection was united at the Legion in the Achenbach Foundation for Graphic Arts, the Museums' department for works on paper.

The Museums have recently renewed their efforts to strengthen the collection and exhibition of photography. A founding curator of photography was appointed in 2010, and a gallery at the de Young is dedicated to a regular rotating presentation of works by landmark photographers.

Left: Arnold Genthe (American, 1869–1942). Printed by Ansel Adams (American, 1902–1984)
Untitled (View of Devastated San Francisco, Framed between Remaining Portals of Towne Mansion on Nob Hill), 1906, printed 1956
Gelatin silver print, 13 1/4 x 10 3/16 in. (33.7 x 25.9 cm)

Museum purchase, James D. Phelan Bequest Fund, 1943.407.130.2

Right: Pierre Dubreuil (French, 1872–1944)
Éléphantaisie, 1908
Gelatin silver print
9 3/4 x 7 11/16 in. (24.7 x 19.5 cm)

Museum purchase, Prints and Drawings Art Trust Fund, 2009.29

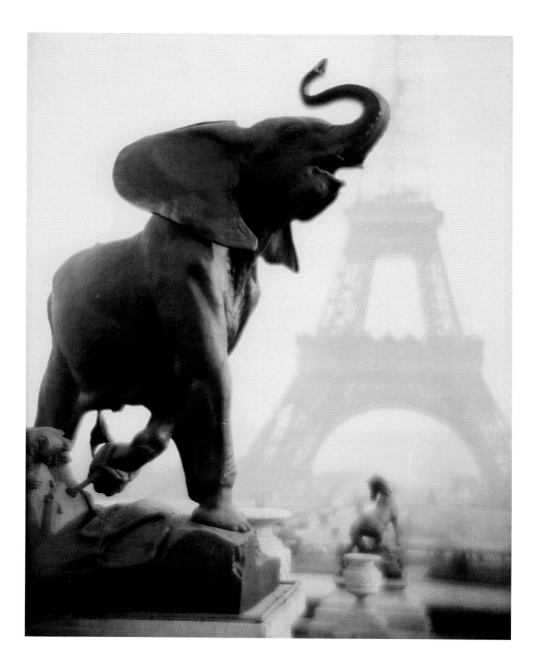

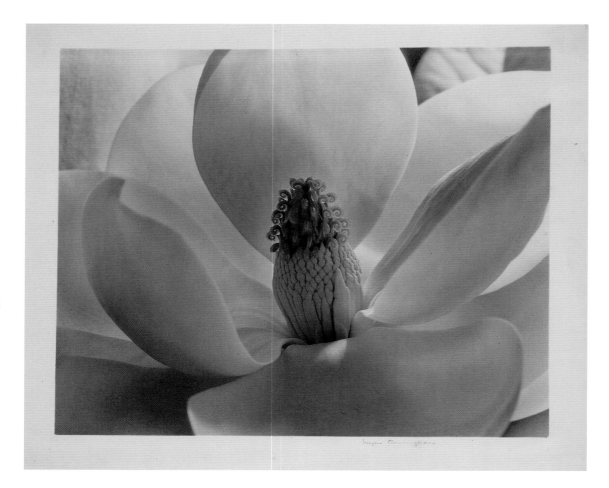

68

Imogen Cunningham (American, 1883–1976)
Magnolia Blossom, 1925, printed 1930
Gelatin silver print
9 5/16 x 11 5/8 in. (23.6 x 29.5 cm)

Museum purchase, M. H. de Young Memorial Museum, 54042

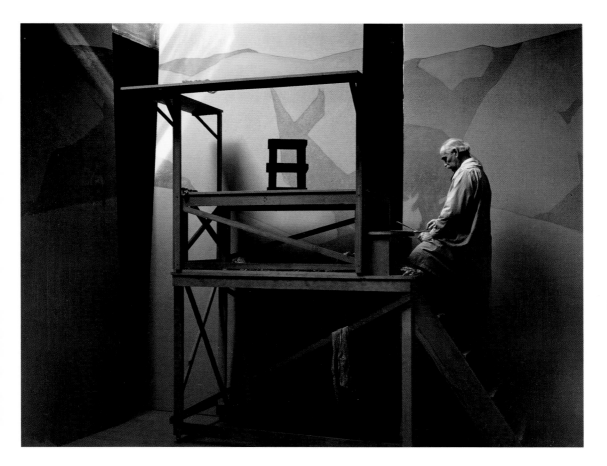

Ansel Adams (American, 1902–1984)
Gottardo Piazzoni in His Studio, 1932
Gelatin silver print
7 x 9 ¹/₈ in. (17.8 x 23.2 cm)

Museum purchase, Pritzker Fund for
Photography in memory of John E.
Buchanan, Jr., 2012.5

Ralph Eugene Meatyard (American,
1925–1972)
Untitled, ca. 1960–1962
Gelatin silver print
Sheet: 7 3/8 x 7 3/8 in. (18.7 x 18.7 cm)

Museum purchase, Pritzker Fund for
Photography, 2011.4.1

Arthur Tress (American, b. 1940)
Untitled (Coit Tower) from the
series *San Francisco, 1964*, 1964,
printed 2010
Selenium-toned gelatin silver print
Sheet: 14 x 11 in. (35.6 x 27.9 cm)

Gift of Steven Rifkin and Nicole
Browning, 2011.27.51

TEOTIHUACAN MURALS

IN THE SUMMER OF 1976 the Fine Arts Museums learned that they were the beneficiaries of a remarkable bequest from someone unknown to them until that time. The late Harald Wagner had willed to the de Young his enormous collection of murals from the ancient city of Teotihuacan, outside Mexico City. How to receive this gift was not immediately clear: in 1971 a treaty of cooperation between Mexico and the United States regarding the return of cultural properties had become law, and the Museums were concerned that this gift might be subject to that agreement. Wagner's papers indicated that he had purchased and brought these fragments into the United States in the 1960s, before the date of the treaty, allowing the will to be settled in 1978 and the Museums to officially acquire the mural fragments.

All the murals were in precarious condition, and every move put them at risk for further damage. The de Young initiated a discussion with Mexican

museum authorities about how best to conserve and exhibit them, beginning a lengthy process that included a joint, yearlong conservation project in public view. After an exhibition of the restored murals at the de Young, the Fine Arts Museums voluntarily returned many of the fragments to Mexico. In all, this process took the greater part of ten years, and it sparked an important partnership between the Fine Arts Museums and INAH (Mexico's Instituto Nacional de Antropología e Historia), including many joint exhibitions, that continues to this day.

The fragments, now displayed in their own gallery in the de Young, feature images of feathered serpents and flowering trees along with glyphs, or picture symbols. The glyphs are as yet undeciphered, but they suggest the advanced and complex culture of an important ancient urban center.

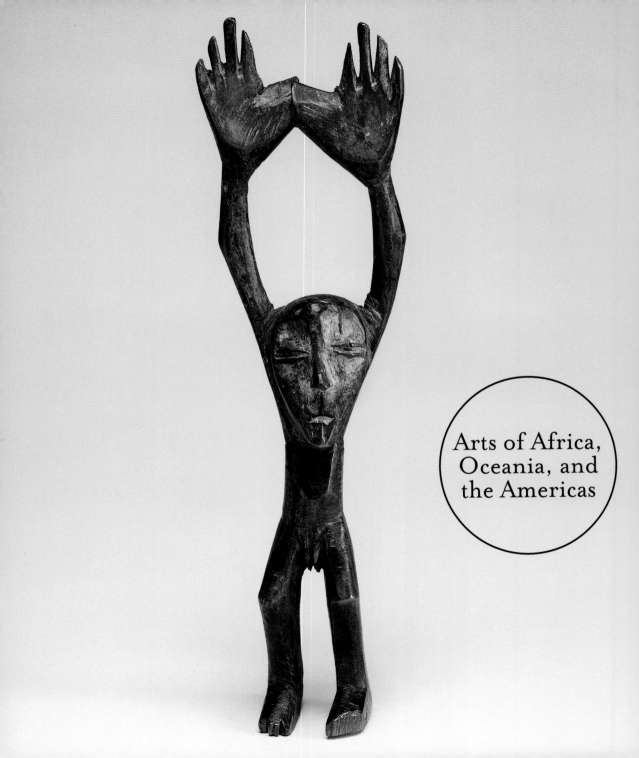

Arts of Africa, Oceania, and the Americas

THE DE YOUNG'S HOLDINGS of art from Africa, Oceania, and the Americas are charter collections of the museum. Many of these works, including significant Oceanic and native North American Indian pieces, were presented at the California Midwinter International Exhibition of 1894 and subsequently purchased for the museum by the City of San Francisco through the efforts of M. H. de Young. In the late 1920s the museum began to acquire major pieces from the ancient Americas, and by midcentury the African holdings, an early but relatively small part of the collection, began to increase significantly.

In 1970 a special department for the arts of Africa, Oceania, and the Americas was created, and in 1973 the de Young opened a new permanent gallery that focused on these works in their cultural contexts. The collections were further enriched during the second half of the twentieth century with arts from the Maya civilization, West Mexico, Indonesia, West Africa, and New Guinea.

In 1986 an unusual and historic bequest by Harald Wagner made the de Young keeper of the largest and most important group of Teotihuacan murals outside Mexico (see pages 72–73), catalyzing an important international cooperative agreement with the nation.

The 2005 opening of the new de Young prompted key purchases of African works, made possible by the Wattis Family Foundation and the Phyllis C. Wattis Fund for Major Accessions, as well as the addition of more than three hundred masterpieces of New Guinea art (see page 83). Gifts in 2007 of Inuit and Eskimo art from the Collection of Thomas G. Fowler and Pueblo pottery from the Paul E. and Barbara H. Weiss Collection (see page 82) stimulated further growth of the Native North American collections, and a multiyear gift of objects from the Erle Loran Family Collection has enriched the museum's African holdings.

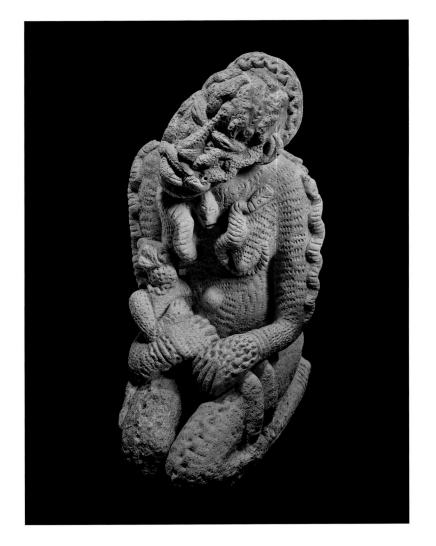

Left: Maternity figure, 12th–15th century
Mali, Djenne people
Earthenware
18 ¾ x 9 x 12 ¼ in. (47.6 x 22.9 x 31.1 cm)

Gift of John and Marcia Friede, 2007.6

Right: El Anatsui (Ghanaian, b. 1944)
Hovor II, 2004
Woven aluminum bottle caps and copper wire
120 x 144 in. (304.8 x 365.8 cm)

Museum purchase, James J. and Eileen D. Ludwig Endowment Fund, Virginia Patterson Fund, Charles Frankel Philanthropic Fund, and various tribute funds, 2004.109

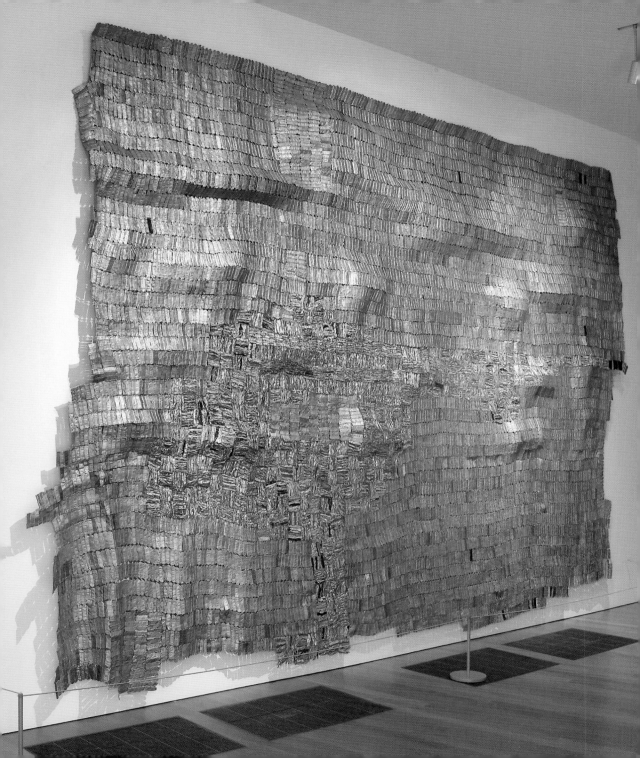

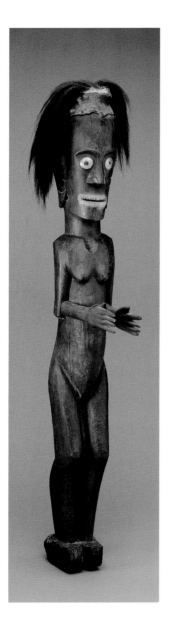

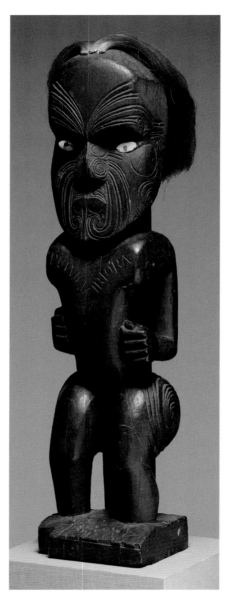

Far left: Protective statue, *pagar*, 19th century
Indonesia, North Sumatra, Toba Batak people
Wood, metal, hide, and horsehair
45 x 5 x 10 in. (114.3 x 12.7 x 25.4 cm)

Gift of George and Marie Hecksher, 2005.140.1

Near left: Tuwhakiriora gable figure, *tekoteko*, ca. 1880
New Zealand, North Island, Māori people, Ngāti Porou tribe
Wood, shell, and hair
55 1/2 x 7 1/2 x 7 3/8 in. (141 x 19.1 x 18.7 cm)

California Midwinter International Exposition, 5522

Right: Johnny Warangkula Tjupurrula (Pintupi/Luritja, 1925–2001)
Children's Story (Water Dreaming for Two Children), 1972
Synthetic polymer paint on composition board
15 7/8 x 18 in. (40.3 x 45.7 cm)

The Gantner Myer Aboriginal Art Collection, 2002.70.2

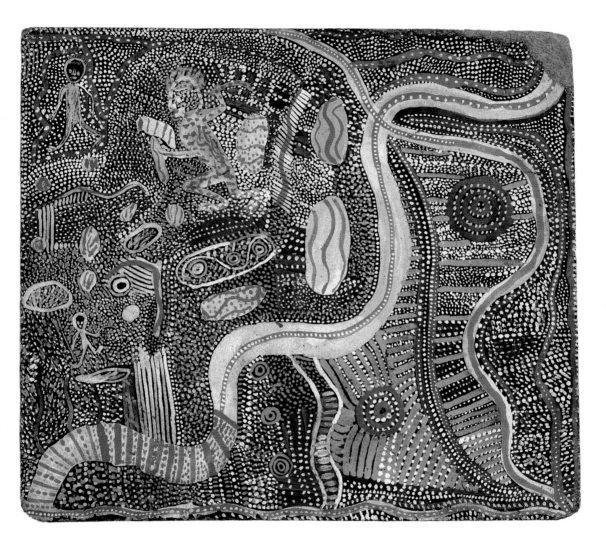

Lidded vessel in the form of a
turtle shell, AD 350–450
Mexico, Central Lowlands, Early
Classic Maya
Earthenware
7 1/2 x 15 5/8 x 15 5/8 in. (19.1 x 39.7 x
39.7 cm)

Gift of Gail and J. Alec Merriam in
memory of Merle Green Robertson,
2011.55.4a–b

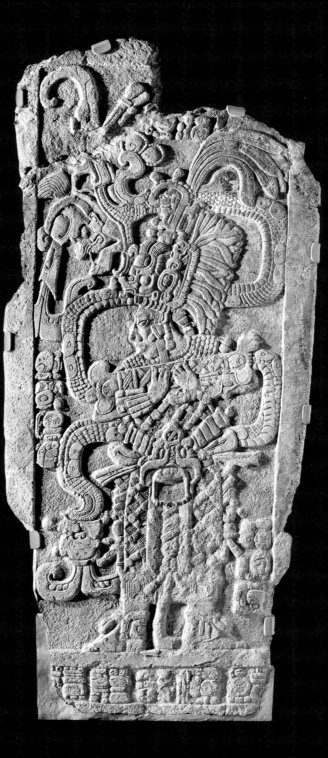

Stela with Queen Ix Mutal
Ahaw, AD 761
Mexico or Guatemala,
Southern Lowlands
Limestone
92 x 45 x 3 in. (233.7 x 114.3 x 7.6 cm)

Museum purchase, gift of Mrs. Paul L.
Wattis, 1999.42

Polychrome jar, ca. 1890–1910
United States, New Mexico,
Acoma Pueblo
Earthenware and pigment
10 3/8 x 11 1/2 x 11 1/2 in. (25.4 x 27.9
x 27.9 cm)

Gift of Paul E. and Barbara H. Weiss,
2007.75.1

Susie Silook (American, Siberian
Yupik/Inupiaq, b. 1960)
Sedna with Mask, 1999
Walrus tusk, sea mammal whiskers,
baleen, whale bone, metal,
and pigment
12 7/8 x 10 x 4 1/4 in. (32.7 x 27.6 x
10.8 cm)

Bequest of Thomas G. Fowler,
2007.21.389

New Guinea Art

IN 2005 THE ACQUISITION of more than three hundred masterworks of New Guinea art marked a new and exciting area of focus for the Fine Arts Museums and turned the de Young into an important exhibition space for Oceanic art. These objects represent some of the finest New Guinea art anywhere in the world, and the gallery that houses them is the largest permanent installation of New Guinea works in any US art museum. Most were gifts from Marcia and John Friede or purchases from the funds established by Mrs. Paul L. (Phyllis C.) Wattis. Six are held in trust for the country of Papua New Guinea as objects of national and cultural importance. Representing the hundreds of clans and art-producing villages throughout the island, these works have multivalent stories to share with visitors and scholars alike. The display reveals the deep history and breadth of New Guinea art styles and promises to transform the public perception of art from this region.

Yipwon (spirit figure),
19th century
New Guinea, East Sepik Province, middle Sepik River, upper Karawari (Korewori) River, Wagupmeri tributary, Yimam (Yimar) people, Alamblak language speakers
Wood
85 7/16 x 11 15/16 x 5 1/2 in.
(217 x 30 x 14 cm)

Museum purchase, Mrs. Paul L. Wattis Purchase Fund, 2000.172.1

83

OSHER GARDEN
OVERLOOK

AT THE WESTERN END of the second-floor galleries a narrow space with seating faces a floor-to-ceiling window that overlooks the Osher Sculpture Garden toward the Japanese Tea Garden. Just under the great cantilever surmounting the café courtyard, it offers visitors a place for a moment of rest and quiet thought.

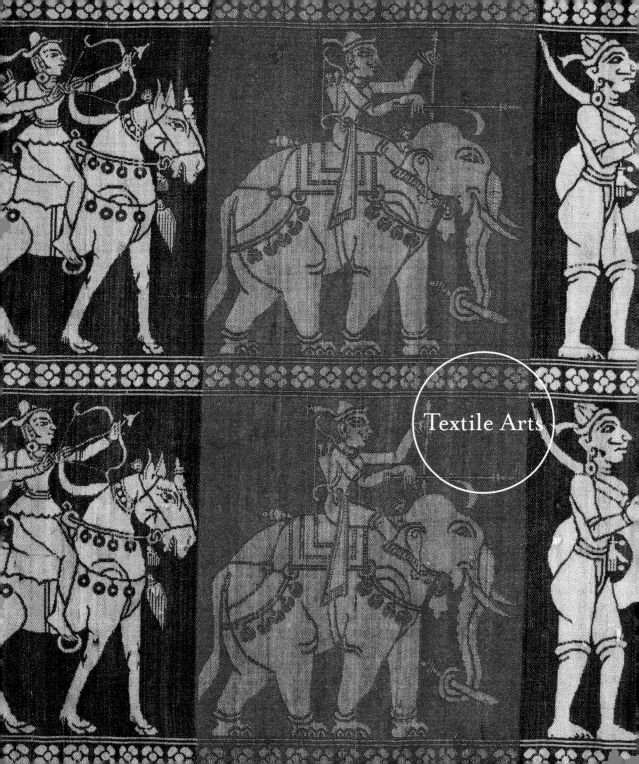

THE CAROLINE AND H. MCCOY JONES Department of Textile Arts boasts more than thirteen thousand artworks spanning two and a half millennia and cultures from 125 countries. It encompasses everything from costumes and costume accessories to loom-woven textiles; nonwoven fabrics such as bark cloth, felt, knitting, and pieced appliquéd leather; and objects decorated primarily with needlework techniques such as beading and embroidery. Highlights include extraordinary Turkmen carpets and the most important group of Anatolian kilims outside Turkey, twelfth- to fifteenth-century Central Asian and North Indian silks (see left), European tapestries, and contemporary fiber art.

Rooted in the museum's origins at the 1894 California Midwinter International Exposition, the textile collections at the de Young have always reflected a wide range of world cultures. Founding objects were joined primarily by European pieces from the Legion of Honor when the institutions merged in 1972. But though both museums collected textiles and costumes from their inceptions, the textile arts department was not established until 1983, when a talented and energetic volunteer, Anna Gray Bennett, led an effort to clean, conserve, and research the tapestry collection, and became the department's first curator.

In the early 1980s a major gift of Central Asian carpets and textiles from H. McCoy Jones and his wife, Caroline, established the de Young's reputation in this area and prompted further acquisitions and exhibitions of non-Western textiles. After Jones's death his wife continued to support the collection through multiple gifts, and the department was named for them to honor this ongoing generosity.

The de Young has been exhibiting fashion since the 1930s and is known for its twentieth-century couture collection, with pieces by important designers such as Christian Dior, Cristóbal Balenciaga, Madame Grès, and Yves Saint Laurent, as well as avant-garde Japanese designers including Issey Miyake, Rei Kawakubo, and Yohji Yamamoto. The museum also houses fans from the eighteenth and nineteenth centuries, an excellent lace collection, and spectacular European ecclesiastical vestments and furnishings.

With the reopening of the de Young in 2005 the textile arts department was given a prominent new home with state-of-the-art exhibition, education, conservation, and storage facilities that doubled the space afforded by the old museum. The Joan Diehl McCauley Textile Study Center and the Textile Education Gallery offer electronic access to the collection, small didactic exhibitions, and study drawers holding representative pieces from the museum's holdings.

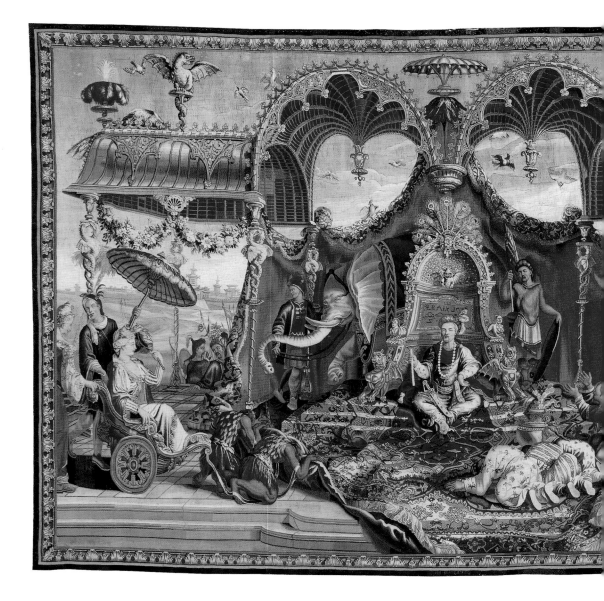

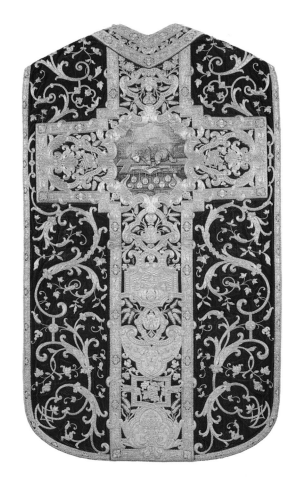

Left: *The Audience of the Emperor*, or
The Chinese Prince's Audience,
1722–1723
France, Beauvais manufactory
Wool and silk; tapestry weave
125 x 198 in. (317.5 x 502.9 cm)

Roscoe and Margaret Oakes Collection,
59.49.1

Chasuble, ca. 1700–1710
France, probably Paris
Silk, metallic threads; cut velvet and
embroidery (laid work, couching,
padded couching, or *nué*)
49 ⅛ x 28 ¾ x 1 in. (124.8 x 73 x
2.5 cm)

Museum purchase, Dorothy Spreckels
Munn Bequest Fund, 2004.9.1.1

Woman's sack-back gown (*robe à la française*), ca. 1765
France
Silk satin brocade trimmed with silk fly fringe; lined with undyed linen and silk

Gift of Mrs. Chauncey Olcott, 55018

Kay Sekimachi (American, b. 1926)
Wave, 1980
Woven book of linen, acrylic paint,
and buckram (lining); double
weave and warp-painting
4 ³⁄₈ x 4 ³⁄₈ x 18 in. (11.1 x 11.1 x
45.7 cm)

Gift of the artist, 2005.124

Christian Dior (French, 1905–1957)
"Soirée Fleurie" ball gown, 1955
France, Paris
Silk satin, polychrome stones, and
silver and silver-gilt strip; embroidery
(couching)

Bequest of Jeanne Magnin, 1987.25.4a–c

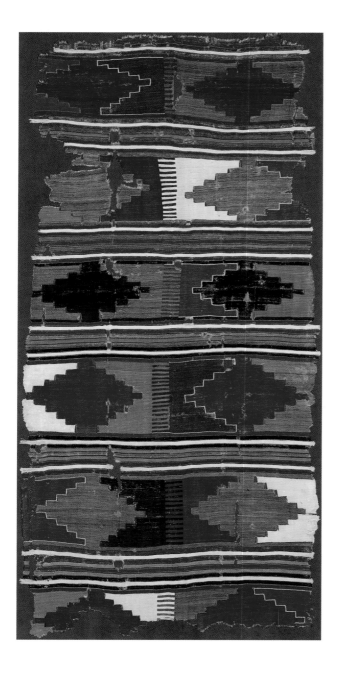

Above: Ceremonial hanging (*palepai*),
19th century
Indonesia, South Sumatra, Lampung
Handspun cotton; plain weave with
supplementary-weft patterning
27 3/16 x 129 15/16 in. (69 x 330 cm)

Museum purchase, Textile Arts Council
Endowment Fund and the Nasaw Family
Foundation Fund, 2010.18

Left: Kilim, 18th–19th century
Turkey, Aegean Region, Usak or
Denizli Province
Wool and cotton; slit-tapestry weave
132 x 71 in. (335.3 x 180.3 cm)

The Caroline and H. McCoy Jones
Collection, gift of Caroline McCoy
Jones, 2000.202.6

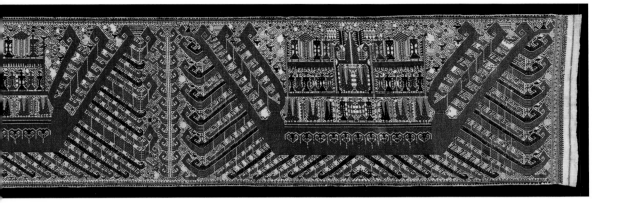

Man's mantle, 1900–1950
Ivory Coast, Dida people
Raffia; oblique interlacing,
stitch-resist dyeing
63 x 72 in. (160 x 182.9 cm)

Museum purchase, Volunteer Council
Acquisitions Fund, 2003.6

NANCY B. AND JAKE L. HAMON TOWER

THE IDEA OF INCLUDING A TOWER as an element of the new de Young grew from the fact that such a feature had been the central focus of the previous building. Housing the staff and resources for an ambitious new program of free educational activities, the Hamon Tower is a symbol of the prominence of education in the life of the new museum.

Architecturally, the 144-foot-high structure signals the presence of the museum in the park and visually links it with the rest of the city. It begins at ground level as an extension of the rectangular

building, but gradually twists and stretches into a parallelogram at the top to align with the street grid of San Francisco. The cantilevered structure provides views from every level while maximizing the usable space on each floor.

Elevators running up the center of the tower afford regular access to each level; exterior stairs allow for emergency egress. The perforated copper veil that encloses the stairs and the entire tower up to the observation level gives it a light, airy appearance that obscures its complicated engineering.

As it is transformed by fog or brilliant sunlight, or by lights shining though the copper walls at night, the tower becomes a fitting icon for the museum and its mission to enlighten.

TOWER LOBBY
RUTH ASAWA SCULPTURES

RUTH ASAWA, an internationally recognized sculptor who has lived and worked in San Francisco for most of her life, took an active interest in the new de Young building, and especially in the development of the tower as a center for education. An emeritus member of the Museums' board of trustees as well as an artist, she has long been a powerful advocate of arts education, and for these reasons the Museums chose to install her work in the tower lobby.

Asawa gave fifteen wire sculptures to the Fine Arts Museums and participated in the discussion about their arrangement and lighting. They represent an overview of her significant work in this medium, beginning in the 1950s. Reflecting light and forming shadows, the natural shapes of the hanging sculptures enrich the open space they inhabit. Their biomorphic forms evoke the beauty and intricacy of the natural world, which has been a source of inspiration for the artist throughout her career. Visitors inevitably pause to enjoy the moment of contemplation and aesthetic pleasure inspired by these works.

Asawa was enthusiastic about installing her sculptures in a location where young students would experience them on their way to art classes, which are held in the upper levels of the tower. She has always believed in the value of art for both young and old, and as an integral part of community life. From bringing up her own children in an environment focused on art making, to ensuring that art programs and objects enrich the schools and communities around them, Asawa has worked continuously to see that art and artists have a prominent place in daily life.

HAMON TOWER
OBSERVATION LEVEL

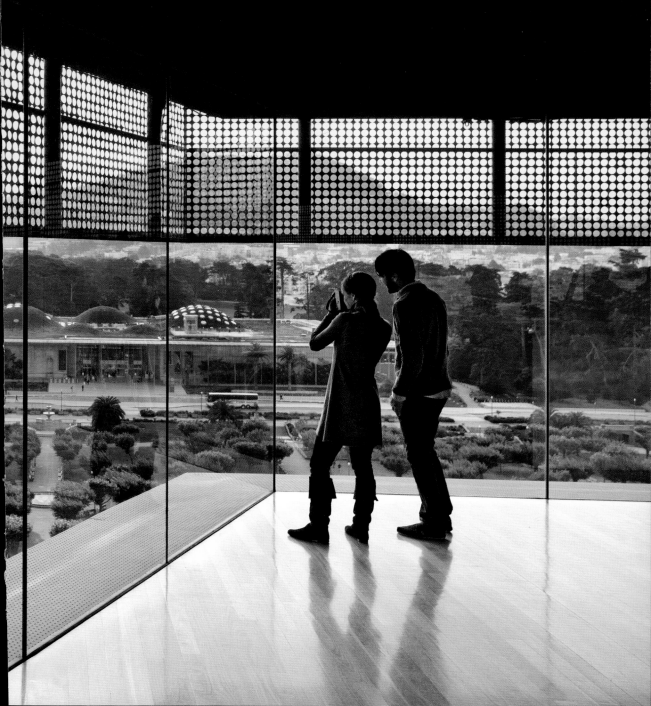

ON THE NINTH FLOOR of the tower a break in the copper screen affords a 360-degree panorama that encompasses views of the Pacific Ocean, downtown San Francisco, and the "Living Roof" of the California Academy of Sciences just across the Concourse. One wall of the elevator bay displays a large satellite picture of the entire city so that visitors can orient themselves in San Francisco as well as the park. On fogless days they can see the Golden Gate Bridge and even the red Mark di Suvero sculpture that marks the location of the Legion of Honor in Lincoln Park.

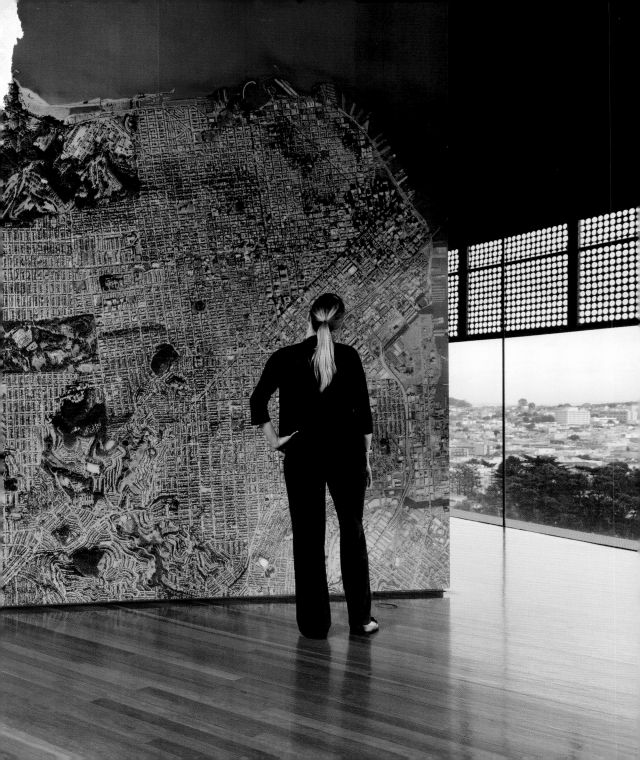

WILLIAM AND
GRETCHEN KIMBALL
EDUCATION GALLERY

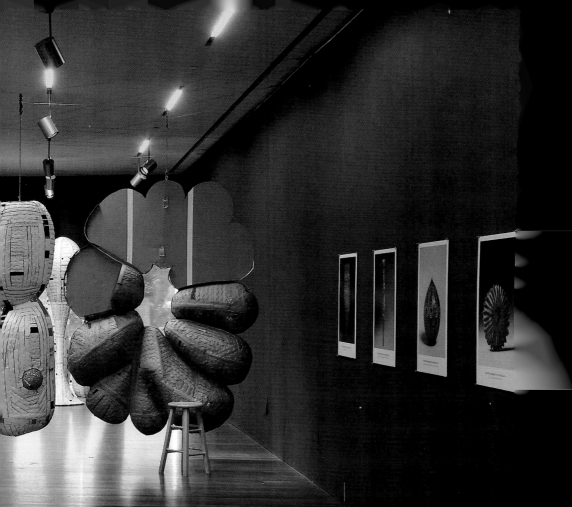

AT THE EASTERN end of the main floor, the Kimball Education Gallery hosts visiting artists in programs developed by the museum's Education Department. The Artist-in-Residence program invites individual artists (such as Ann Weber, whose art is shown here), rotating on a monthly basis, to install and demonstrate their work in this designated space, welcoming interactions with visitors of all ages. During some months the gallery features

participants in the Artist Fellows progra long collaboration with artists and comr partners to produce new pieces in resp museum's collections, exhibitions, and ment. These works are visible from the the de Young through the gallery's larg inviting the public to enter the museur pate in the experience.

DE YOUNG
MUSEUM STORE

THE MUSEUM STORE in the de Young occupies two floors connected by an interior stone staircase and by elevators just outside the doorways. Wide entrances invite visitors to peruse a broad selection of books and gift items that relate to the museum's collections and exhibitions. The lower level features art books, posters, and stationery, as well as a large children's section. On the upper level are jewelry, crafts, gifts, reproductions, and decorative items. Catalogues and books for current exhibitions are displayed outside both entrances. Special stores are also often placed adjacent to temporary exhibitions, joining with the permanent store to complement the museum's educational mission.

Africa, Oceania, the Americas, and The Jolika Collection of New Guinea Art. San Francisco: Fine Arts Museums of San Francisco, 2009.

Bennett, Anna Gray. *Five Centuries of Tapestry from the Fine Arts Museums of San Francisco*. Rev. ed. San Francisco: Fine Arts Museums of San Francisco and Chronicle Books, 1992.

Berrin, Kathleen, ed. *Feathered Serpents and Flowering Trees: Reconstructing the Murals of Teotihuacan*. San Francisco: Fine Arts Museums of San Francisco, 1988.

Burgard, Timothy Anglin, and Daniell Cornell, with Isabel Breskin, Amanda Glesmann, Elizabeth Leavy, and Kevin Muller. *Masterworks of American Painting at the de Young*. San Francisco: Fine Arts Museums of San Francisco, 2005.

Cootner, Cathryn M., with Garry Muse. *Anatolian Kilims: The Caroline and H. McCoy Jones Collection*. San Francisco: Fine Arts Museums of San Francisco in association with Hali, London, 1990.

Dreyfus, Renée. *De Young: Selected Works*. San Francisco: Fine Arts Museums of San Francisco in association with Scala, London, 2005.

Fine Arts, Spring/Summer 2005 and Fall/ Winter 2005–2006. A publication of the Fine Arts Museums of San Francisco for museum members.

Forbes, Pamela, ed. *100 Years in Golden Gate Park: A Pictorial History of the M. H. de Young Memorial Museum*. San Francisco: Fine Arts Museums of San Francisco, 1995.

Friede, John A. *New Guinea Art: Masterpieces from the Jolika Collection of Marcia and John Friede*. San Francisco: Fine Arts Museums of San Francisco in association with 5 Continents Editions, Milan, 2005.

Ketcham, Diana, with Michael R. Corbett, Mitchell Schwarzer, and Aaron Betsky. *The de Young in the 21st Century: A Museum by Herzog & de Meuron*. San Francisco: Fine Arts Museums of San Francisco in association with Thames & Hudson, London, 2005.

The Official History of the California Midwinter International Exposition. Compiled and edited by Alexander Badlam, Executive Secretary of the Exposition, and F. H. Trusdell, Chief of the Department of Publicity and Promotion. San Francisco: Press of H. S. Crocker Company, 1894/copyright 1895.

Roberts, Mary Nooter, and Allen F. Roberts. *The Shape of Belief: African Art from the Dr. Michael R. Heide Collection*. San Francisco: Fine Arts Museums of San Francisco, 1996.

Stover, Donald L. *American Sculpture: The Collection of the Fine Arts Museums of San Francisco*. San Francisco: Fine Arts Museums of San Francisco, 1982.

Sutton, Denys, ed. *The Fine Arts Museums of San Francisco*. Originally published in *Apollo Magazine* 11, no. 216 (February 1980) and no. 217 (March 1980). Two issues bound as one publication.

ACKNOWLEDGMENTS

THE FINE ARTS MUSEUMS of San Francisco wish to thank the many individuals whose leadership and cooperation helped to make this book a reality, including Diane B. Wilsey, President of the Board of Trustees, as well as the officers at the Museums, Richard Benefield, Deputy Director; Michele Gutierrez-Canepa, Chief Administrative Officer and Chief Financial Officer; and Julian Cox, Founding Curator of Photography and Chief Administrative Curator.

The Museums also give thanks to our partners at Glue + Paper Workshop, Amanda Freymann and Joan Sommers, as well as our author, Ann Heath Karlstrom, and our proofreader, Susan Richmond. At the Museums, Danica Hodge managed the production, with extensive assistance from Lucy Medrich. We also thank Karen Levine, former Director of Publications, who began this project, and Leslie Dutcher, Director of Publications, who completed it.

The Museums' curatorial staff made essential contributions to sections pertaining to their respective departments, including Timothy Anglin Burgard and Emma Acker, for American and contemporary art; Christina Hellmich and Bianca Alper, for arts of Africa, Oceania, and the Americas; Jill D'Alessandro, for textile arts; and Julian Cox, for photography.

Additional staff who aided in this project include Stuart Hata and Tim Niedert, from the Museum Stores, who made excellent suggestions during the conceptual and production phases of the book; Patty Lacson, Greg Zaharoff, Mike Badger and the Museums' engineering staff, and Hugo Gray and the Museums' security staff, who all provided support during new photography of the building; and Sue Grinols, Joe McDonald, Jorge Bachmann, Debra Evans, Jane Glover, and Andrew Fox, who all contributed additional photography.

Our esteemed photographer, Henrik Kam, and his colleagues provided impeccable services with patience and flexibility. Jim Jackson and James McCormick of San Francisco Recreation and Parks were gracious in aiding our building photography in Golden Gate Park; Helen Taylor, from the California Academy of Sciences, was helpful in arranging for us to shoot from that building's roof; and Thomas Sotelo and Rosalia Schoemaker from McCalls provided services on behalf of the Museum Cafés.

Finally, we would like to acknowledge many other individuals for their participation in this project: Neda Asgharzadeh, Liz Austerman, Renee Baldocchi, Brandon Ballog, Hannah Battat, Ashley Bedell, Victoria Binder, Rose Burke, Isabella Castillo, Louis Chan, Kelly Anne Chin, Bill Chow, Helen Chun, Morrison Chun, Stephen Chun, Rebecca Crump, Julia Doherty, William Doherty, Robert Gardali, Mark Garrett, Tasman Grant, Clara Hatcher, Ava Hodge, Emma Hosking, Sophia Hosking, Kathy Lassen-Hahne, Christopher Lentz, Susan Leurey, Jessica Lo, Jack Louie, Martin Luk, Peter Narodny, Zeynep Oguz, Zhen Liang Peng, Juliana Pennington, Sam Rogerson, Kristen Seki, Emmy Sharp, Gregory Stock, Travis White, Michael Wong, and Joseph Yan.

109

Pages 6, 30–31: Andy Goldsworthy (English, b. 1956). *Drawn Stone*, 2005. Appleton Greenmoor sandstone. Museum purchase, gift of Lonna and Marshall Wais, 2004.5

Page 29: (Top) Gustave Doré (French, 1832–1883). *Poème de la vigne*, 1877–1878 (cast 1882). Bronze. H: 11 ft. (3.35 cm). Gift of M. H. de Young, 53696. (Bottom) Arthur Putnam (American, 1873–1930). *Sphinx*, ca. 1910. Concrete. Gift of M. H. de Young to the City of San Francisco

Page 32: Gerhard Richter (German, b. 1932). *Strontium*, 2004. 130 C-print photographs mounted on aluminum, 358 1/4 x 372 1/16 in. (910 x 945 cm). Foundation purchase, gift of Diane B. Wilsey, President, Board of Trustees, Fine Arts Museums of San Francisco, on the occasion of the opening of the New de Young Museum on October 15, 2005, in memory of Alfred S. Wilsey, 2004.6

Pages 34–37: Gottardo Piazzoni (American, b. Switzerland, 1872–1945). *The Sea* and *The Land* (detail), 1931. Oil on canvas, two sets of five panels, each 144 x 80 in. (365.8 x 203.2 cm). Transfer from the San Francisco Art Commission and the Asian Art Museum through the Joint Committee to Site the Piazzoni Murals, 1999.196.1a–e, 1999.196.2a–e

Page 52

Page 38: Albert Bierstadt (American, 1830–1902). *View of Donner Lake, California* (detail), 1871–1872. Oil on paper mounted on canvas, 29 1/4 x 21 7/8 in. (74.3 x 55.6 cm). Gift of Anna Bennett and Jessie Jonas in memory of August F. Jonas, Jr., 1984.54

Pages 46–47: (Front) Gustav Kraitz (Swedish, b. 1926). *Apples*, 2005. Glazed ceramic, each 17 1/2 x 16 1/2 x 16 1/2 in. (44.5 x 41.9 x 41.9 cm). Gift of Barbro and Bernard A. Osher to the Fine Arts Museums Foundation, 2005.94.1–12. (Center right) Juan Muñoz (Spanish, 1953–2001), *Conversation Piece V (Three Figures)*, 2001. Bronze, each 64 x 31 3/8 x 31 3/8 in. (162.6 x 79.7 x 79.7 cm). Foundation purchase, gift of Barbro and Bernard A. Osher, 2005.125a–c

Page 48: Claes Oldenburg (American, b. Sweden, 1929) and Coosje van Bruggen (American, b. The Netherlands, 1942–2009). *Corridor Pin, Blue*, 1999. Stainless steel, aluminum, and polyurethane enamel, 255 x 254 x 16 in. (647.7 x 645.2 x 40.6 cm). Foundation purchase, gift of the Barbro Osher Pro Suecia Foundation, 2003.66a–b

Page 49: Barbara Hepworth (English, 1902–1975). *Pierced Monolith with Colour*, 1965. Roman stone and paint, 68 1/2 x 46 x 8 in. (174 x 116.8 x 20.3 cm). Foundation purchase, gift of Barbro and Bernard A. Osher, 2003.110

Pages 50–51: James Turrell (American, b. 1943). *Three Gems*, 2005. Concrete, plaster, stone, and neon lighting. Foundation purchase, gift of Barbro and Bernard A. Osher, 2003.68

Page 52: Kiki Smith (American, b. 1954). *Near* (detail), 2005. Aluminum, copper leaf, and blown glass, 156 x 492 x 288 in. (396.2 x 1249.7 x 731.5 cm). Museum purchase, Dorothy and George Saxe Endowment Fund and the Friends of New Art, 2004.94

Page 64: Eadweard Muybridge (American, 1830–1904). *View from the Window of 605 O'Farrell Street, San Francisco* (detail), from the album *Home*, 1880. Albumen silver print, 7 x 9 in. (17.8 x 22.8 cm). Museum purchase, Achenbach Foundation for Graphic Arts Endowment Fund and the Jacqueline Roose Fund in honor of Robert Flynn Johnson, 2003.70.37

Pages 72–73: Teotihuacan murals, AD 400–750. Mexico, Teotihuacan, Techinantitla. Volcanic ash, lime coating, pigment, and mud backing. Bequest of Harald J. Wagner, 1985.104.1–14

Page 74: Standing figure, 19th century. Democratic Republic of Congo, Lega people. Wood and kaolin, 12 x 3 1/4 in. (30.5 x 8.3 cm). Museum purchase, gift of Mrs. Paul L. Wattis and the Fine Arts Museums Acquisition Fund, 1986.16.5

Page 86

Page 86: Fragment (detail), 13th–15th century. India, North India (?), Sultanate period. Silk; weft-faced compound twill (*samit*), 7 1/16 x 7 9/16 in. (18 x 19.2 cm). Gift of George and Marie Heckscher, 2000.186.1

Pages 96–97: Ruth Asawa (American, b. 1926). Untitled works, 1960s. Copper and brass wire; monel wire (copper and nickel alloy); and galvanized iron wire, various sizes. Gifts of the artist, 2005.90.5–8 and 2005.90.11

Page 38

Page 64

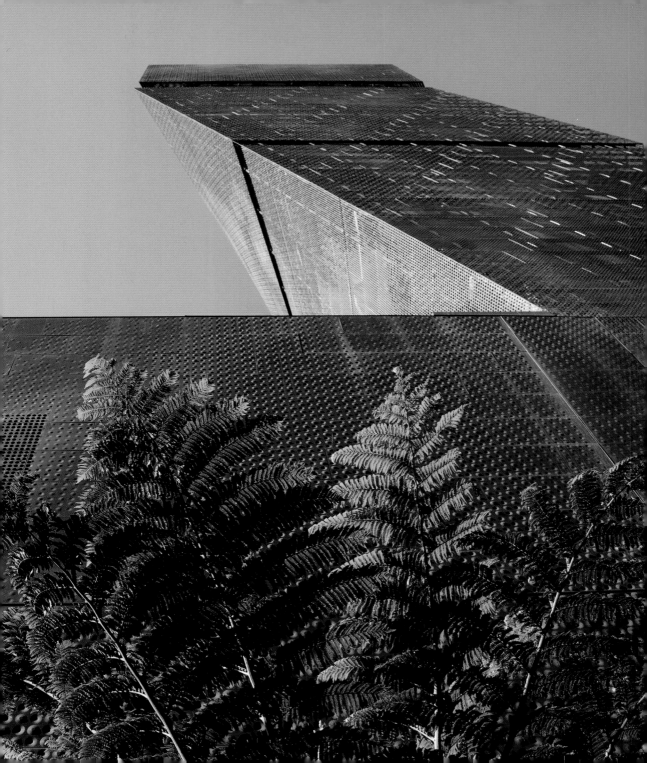

Published by the Fine Arts Museums of San Francisco

Fine Arts Museums of San Francisco
Golden Gate Park
50 Hagiwara Tea Garden Drive
San Francisco, CA 94118-4502
www.famsf.org

Leslie Dutcher, Director of Publications
Danica Hodge, Editor
Lucy Medrich, Associate Editor

Project Management by Danica Hodge
Copyedited by Lucy Medrich
Proofread by Susan Richmond

Produced by Glue + Paper Workshop LLC, Chicago
 Designed and typeset by Joan Sommers
 Production management by Amanda Freymann
Color separations by Professional Graphics, Inc.
Printed and bound in China by Asia Pacific Offset

Library of Congress Cataloging-in-Publication Data

M.H. de Young Memorial Museum.
 De Young : inside and out / introduction by Ann Heath Karlstrom ; new photography by Henrik Kam.
 pages cm
 ISBN 978-0-88401-135-4
 1. M.H. de Young Memorial Museum. I. Title.
 N739.5.A833 2013
 708.194'61—dc23

 2012044806

Unless otherwise noted in the captions, all artworks reproduced in this book are from the collection of the Fine Arts Museums of San Francisco.

Dimensions for drawings and paintings indicate the size of the sheet or unframed canvas. Dimensions for prints and photographs document image size. Height precedes width. For three-dimensional objects, dimensions are listed in order of height, width, and depth.

Back cover, left to right: George Caleb Bingham, *Boatmen on the Missouri*, 1846, detail of page 40. Ruth Asawa, untitled works, 1960s, detail of pages 96–97. Hamon Tower observation level, detail of photograph by Henrik Kam, © FAMSF